POSTCARD HISTORY SERIES

Denton County

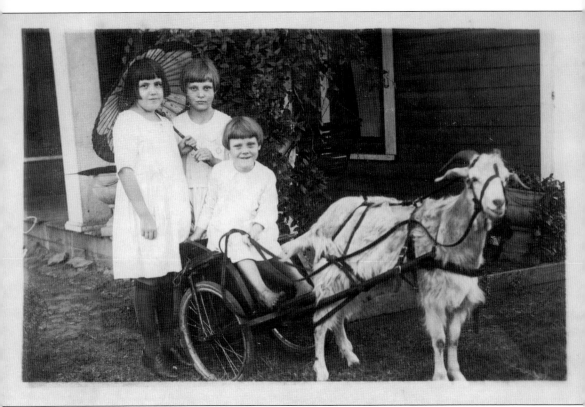

GOAT CART AND CHILDREN. In the 1920s and 1930s, itinerant photographers traveled throughout the United States with goat carts and took photographs of children. Sometimes the photographer provided the goat, thus many photographs featured the same animal. One enterprising photographer posed children on the White House lawn. Even though none of the little girls in this postcard grew up to be president, they are, from left to right, Willie Lee Taylor, Hollie Jo Alexander, and Jenny Alexander (seated in the cart), Will Taylor's daughter and his cousin's children. (Unknown publisher, real photo, *c.* 1920.)

ON THE FRONT COVER: **COURTHOUSE DURING MARKET DAY.** This scene of a cow on the Courthouse-on-the-Square lawn is not something one might expect. It was not an unusual sight to see farmers and merchants and their wagons on the downtown square, especially during market days. However, a cow grazing on the lawn must have been an amusing story for merchants and passersby to talk about even in 1913. (Duke and Ayres Nickel Stores, *c.* 1913.)

ON THE BACK COVER: **LITTLE ELM BAND.** Little Elm was one of the earliest settlements in Denton County. The family of John and Delilah King arrived in 1844 settling along the banks of Little Elm Creek. Christopher Columbus "Kit" King operated the first post office in the county out of his home. Despite being bypassed by the railroad, Little Elm grew as a community due to the town's close proximity to water and roads. In 1908, the town boasted a brass band and a baseball team. (Unknown publisher, real photo, 1909.)

POSTCARD HISTORY SERIES

Denton County

Jim Bolz, Tricia Bolz, and the Denton County Museums

ARCADIA
PUBLISHING

Published by Arcadia Publishing
Charleston SC, Chicago IL, Portsmouth NH, San Francisco CA

Printed in the United States of America

Library of Congress Control Number: 2009937663

For all general information contact Arcadia Publishing at:
Telephone 843-853-2070
Fax 843-853-0044
E-mail sales@arcadiapublishing.com
For customer service and orders:
Toll-Free 1-888-313-2665

Visit us on the Internet at www.arcadiapublishing.com

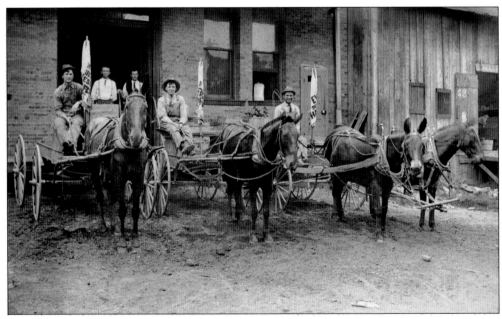

L. L. PUCKETT GROCERY STORE. This real photograph was taken behind L. L. Puckett's Grocery Store located on the east side of the square at 114 North Locust Street. By 1929, the Woodson A. Harris Grocery Store had taken over the Puckett location selling staples and fancy groceries. The men in the photograph are, from left to right, Guy Taylor, Jack Jones, Pat Gallagher, Hugh Skiles, and Jack Skiles, employees of the store. The store offered delivery service to its customers. (Unknown publisher, real photo, *c.* 1919.)

CONTENTS

ACKNOWLEDGMENTS

Jim and Tricia Bolz are collectors of all things Denton, including bottles, advertising materials, banks, business invoices and receipts, old letters, and of course, postcards. They own the largest number of Denton County postcards at 550 and counting. Jim approached the Denton County Museums's executive director, Georgia Caraway, and curator of collections, Kim Cupit, about compiling a book based on his and Tricia's collection to benefit the museums. Having just completed the Arcadia book, Images of America: *Denton*, Georgia and Kim were eager to create this companion book of historic postcards, and the rest, as they say, is history. Georgia and Kim did all of the research and writing, but the book could not have been produced without the generosity of Jim and Tricia Bolz.

The authors wish to thank the following for helping us during the process of compiling and writing this book: members of the Denton County Historical Commission and the Denton County Commissioners Court for their unwavering support, Lee J. Capps for his encyclopedic knowledge of dating cars, and Martha Len Nelson, whose roots grow deep in Denton County history.

We consulted previously written books about Denton County, including *GIC,0 CIA, TSCW, TWU Traditions 1901–2001*; *Marking a Trail, a History of the Texas Woman's University* by Joyce Thompson; *Marking a Trail: the Quest Continues* by Phyllis Bridges; *An Illustrated History of Denton County* by Dale Odom; *Down the Corridor of Years* by Richard Himmel and Bob La Forte; *History and Reminiscences of Denton County* by Ed F. Bates; *History of Denton, Texas* by C. A. Bridges; *The Story of North Texas I and II* by James L. Rogers; the *Denton Record-Chronicle* newspaper articles; and research materials and articles by Mike Cochran, Bullitt Lowry, Sylvia Barlow Greenwood, Nita Thurman, and the various Denton churches.

Once again we wish to thank the staff of Arcadia Publishing (especially Luke Cunningham) for making this an enjoyable experience. We encourage anyone with stories of his or her community to contact Arcadia.

Special acknowledgment goes to the staff of the Denton County Museums for watching over the museums while we put this book together.

Jim and Tricia dedicate this book to their twin daughters, Peyton and Morgan, precious gifts from God. Georgia and Kim want to dedicate this book to collectors of all types, but especially to those who are discovering and keeping the history of their communities alive through photographs and postcards.

The postcards in this volume are from the collections of Jim and Tricia Bolz, the Denton County Museums (DCM), and Mike Cochran (MC). Unless otherwise acknowledged, the postcards are from the Bolz collection.

INTRODUCTION

The Texas Legislature created Denton County on April 11, 1846. John B. Denton, a pioneer preacher and lawyer who was killed in an Indian battle in 1841, was the city and county's namesake. Pinckneyville was the first county seat but lacked water and was not centrally located to the other settlements in the county. The county seat moved three times before finally locating to the city of Denton in 1857. The city of Denton is located in the geographic center of the county on Pecan Creek. A 100-acre tract was donated by Hiram Cisco, William Loving, and William Woodruff. The city streets were platted and named after trees that grew in the county. Lots were auctioned on January 10, 1857, and the downtown square became the primary business and market area.

The first courthouse was constructed on the north side of the square in 1857. Built primarily of wood, it burned on Christmas Eve 1875. A brick structure was built in the center of the square, but in 1895 it was condemned by commissioners court, then struck by lightning, and was later demolished. Construction began on the Courthouse-on-the-Square in 1895, the cornerstone was laid in 1896, and the courthouse was dedicated in 1897. The building was designed by W. C. Dodson with Tom Lovell as contractor. The courthouse was built of cream-colored limestone quarried on the Ganzer farm north of Denton and hauled to the construction site by mules and wagons. There are 82 Burnet County granite columns with caps and bases of Pecos red sandstone. The tan sandstone is from Mineral Wells. The courthouse was designated an official Texas Historic Landmark in 1970 and named to the National Register of Historic Places in 1977. The Courthouse-on-the-Square houses the county judge and county commissioners' offices. The Courthouse-on-the-Square Museum, Denton County Historical Commission, and museum offices and research facilities are also in the historic courthouse building.

Months after the establishment of the city of Denton, the first religious congregation was organized by Methodist circuit minister William E. Bates. Bates was assigned to the Alton Circuit by the Methodist Episcopal Church, South. He helped establish many churches in Denton County. The Baptists were the next to organize a church, followed by the Cumberland Presbyterian and the Christian congregations. Most services were held in the courthouse and the Masonic Hall until the Presbyterians constructed the first church building in 1871. Other congregations soon constructed their own buildings.

The first schools in Denton were subscription schools located in private homes and public buildings. In 1881, Denton became an independent school district. The first public school building was constructed in 1884 and served all students until a second school, called the North Ward School, was built in 1899. It was followed by the West Ward School in 1905. The original Central School contained all grade levels until 1912 when the high school students moved to their own campus, Denton High School.

Denton embarked on a course that made it a center for higher education when the North Texas Normal College, now the University of North Texas, was established in 1890, and the College of Industrial Arts, now Texas Woman's University, was created in 1901. More than 50,000 students attend these two universities, creating an economic engine that fuels the city's and the county's prosperity.

The first settlers arrived in Denton County in the 1840s as part of the Peters Colony. The Texas Emigration and Land Company opened the North Texas area and offered 640 acres of land to any married man and 320 acres to single men to build a homestead. Pioneers began constructing their homes in the wilderness along the Trinity River and its tributaries during the days of the Republic of Texas. The first settlements were established near Hebron in the southeast corner of the county, in Little Elm to the east, in Pilot Point to the northeast, and in Lewisville to the south. Pioneer settlements soon spread north and south through the East Cross Timbers and into the Grand Prairie.

The landscape of the county changed in the 1880s with the arrival of the railroads. The Texas and Pacific; the Missouri, Kansas, and Texas; and the Gulf, Colorado, and Santa Fe Railroads laid tracks in the early 1880s. Some already existing towns, like Denton, Lewisville, and Pilot Point, benefited from the building of rail stations. Other towns were established by the railway companies as stops along the route. Sanger, Ponder, Justin, and Krum were all founded by the Gulf, Colorado, and Santa Fe Railroad. Communities, such as Bolivar, became ghost towns when they were bypassed by the railroad. The close proximity to Little Elm Creek, and later Lake Dallas and Lake Lewisville, prevented Little Elm from experiencing the same fate.

The first widely distributed pictorial postal cards in the United States were souvenir items for the Columbian Exposition in 1893. The artwork was printed on the backs of governmental postal cards. Private companies produced pictorial cards on nongovernment-printed cards; however, these cards required the higher postage of letter mail. The disparity in postage in the United States between government postals and privately printed cards was eliminated in 1898 by the Private Mailing Card Act.

The term "pioneer view" postcards indicates cards that were published, but not necessarily mailed, before the Act of Congress on May 19, 1898, which became effective on July 1, 1898, to allow privately printed postcards the same postal privileges as the government issues. Previously, privately printed cards with messages had required 2¢ postage rather than the 1¢ required on the government postal cards. "Undivided back" cards are those that were published before 1907 in the United States when only the address could be written on the back of the postcard. "Divided back" cards began in the United States after 1907 with the address side divided so that a message could be written on half of the space. A "real photo" postcard is a picture postcard made directly on photographic paper with a "postcard" back.

E. C. Kropp of Milwaukee and the Albertype Company of New York were two of the major publishers of postcards in the United States. These private publishers offered view cards, holiday greetings, topical, and artist-signed picture postcards in ever-increasing numbers.

View cards are based on realistic images showing places, events, people, and things identified with a specific geographic place. Most view cards are published and marketed locally. Collectors often target specific topics, including railroad depots, advertising, courthouses, churches, greeting cards, transportation, patriotism, African American history, and those designed by a particular artist. Postcards of every topic were produced. Popular topics of Denton County postcards were of the Courthouse-on-the-Square, public schools, businesses, and churches. The two universities, as is evidenced by the prolific number of postcards in the Bolz collection, were popular cards produced of Denton County.

Postcards, like photographs, convey a way of life and pride of place. Denton County, Texas, has many things of which to be proud.

One

Courthouse-
on-the-Square

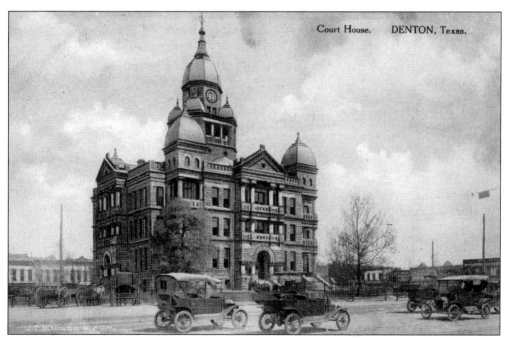

1896 Courthouse. The Denton County Courthouse-on-the-Square is the most popular image featured on postcards. Constructed in 1896 and completed in 1897 at a cost of $179,000, the courthouse was designed by W. C. Dodson and built primarily of limestone from the William Ganzer farm quarry. The courthouse currently houses the offices of the county judge, commissioners' court, and the historical commission and county museum. The 1896 courthouse is a Texas Historic Landmark and is on the National Register of Historic Places. (J. D. Hodges and Sons by Albertype, *c.* 1914.)

RAILWAY COMMEMORATIVE CARD. This Missouri, Kansas, and Texas (the Katy) Railway Company postcard commemorates the railway industry in the city of Denton. The first Katy train reached Denton in 1881. The last Katy passenger train ran in December 1958. The Katy Railroad issued this pioneer postcard after the May 19, 1898, act of Congress authorizing mailing with 1¢ domestic and 2¢ foreign postage. (Pioneer Postcard, *c.* 1898.)

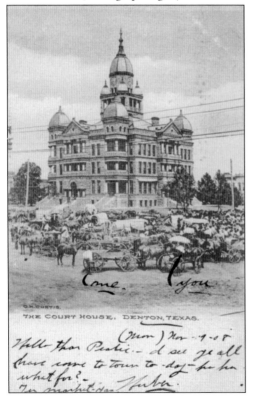

MARKET DAYS ON THE SQUARE. Market days on the downtown square were social and commercial events that drew citizens from all over the county. The handwritten message on the front of this postcard reads, "(Mon) Nov. 9, '08. Hello there Peachie—I see ye all have come to town to-day—ha ha. What for? Huber." The writer marked one wagon "me" and another wagon "you." (O. M. Curtis, *c.* 1908.)

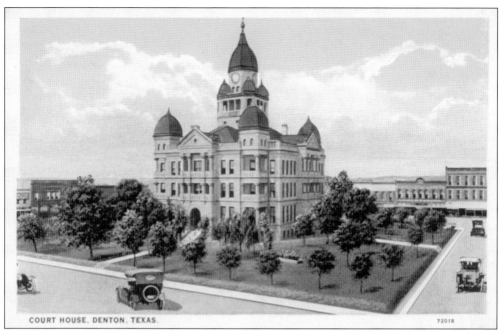

COURT HOUSE, DENTON, TEXAS. 72018

COURTHOUSE WITH EARLY AUTOMOBILE. The first automobiles arrived in Denton in 1907. This tinted card is a courthouse view with early-model automobiles. The message written on this card references the speed of the mail service to and from Denton to Dallas. "I can mail [this card] early in the morning at the branch off[ice] here on the hill and see if it reaches you as early as the one I mailed at the depot when I arrived." (C. T. American Art, *c.* 1919.)

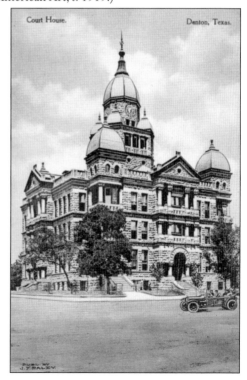

Court House. Denton, Texas.

COURTHOUSE DRAWING. This postal card depicts a drawing of the Courthouse-on-the-Square, published by J. F. Raley to be sold in his drugstore on West Hickory Street on the downtown square. It is a divided-back postcard. (J. F. Raley by Albertype, *c.* 1918.)

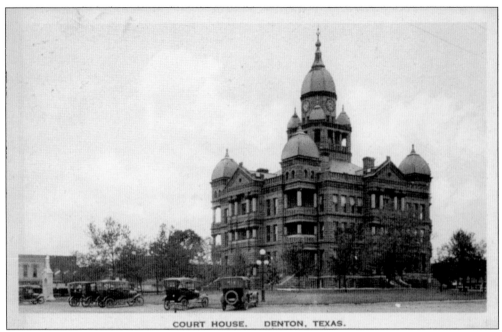

COURT HOUSE. DENTON, TEXAS.

COURTHOUSE. This postcard was mailed on February 25, 1925, seven years after the installation of the Confederate Soldier Monument on the south side of the square. The Daughters of the Confederacy dedicated the monument on June 3, 1918. The Denton Water, Light, and Power Company installed the electric light posts between 1892, when the first power plant was built in the city, and 1925. O. M. Curtis, another drugstore owner on the square, published this card for sale in his store. (O. M. Curtis by Albertype, *c.* 1925.)

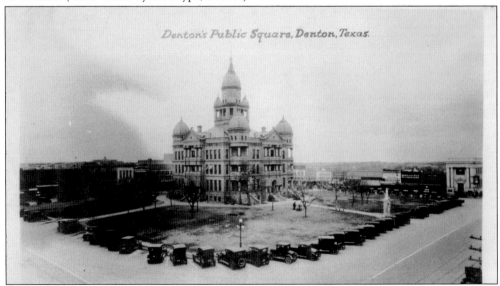

Denton's Public Square, Denton, Texas.

DENTON'S PUBLIC SQUARE. This is a real photograph of the courthouse published sometime after 1917 as is evidenced by the presence of the Denton County National Bank building and its landmark clock on the southeast corner of the square on Locust Street. The presence of the Confederate Soldier Monument dates the card to later than 1918. (Photo and Art Postal Card Company, real photo, *c.* 1920.)

DENTON COUNTY COURTHOUSE. This natural color drawing is from a photograph by Charles E. Carruth. He was a prominent photographer whose studio was at various times in the May Building and at 124 South Austin Street. There is a distinctive style to Carruth photographs, making them recognizable to aficionados of his work, which was copied by artists for many Denton postcards. (C. E. Carruth by E. C. Kropp, 1930s–1940s.)

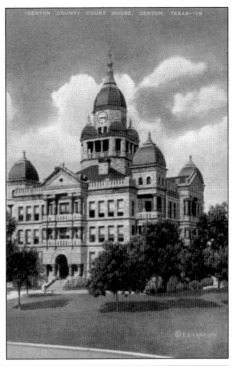

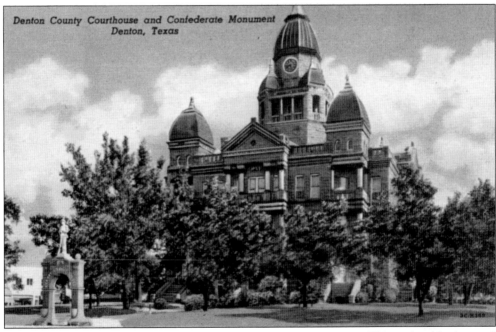

DENTON COUNTY COURTHOUSE AND CONFEDERATE MONUMENT. This undated "colortone" card was produced for distribution by the Fultz News Agency, which was in business on the east side of the square from 1939 until the late 1980s. The text printed on the back of the card provides information on the style of the courthouse, "The unusual architecture of this building has attracted favorable comments from thousands of visitors. The stone used in this building is a product of Denton County." (Fultz News Agency by Curt Teich, 1950s.)

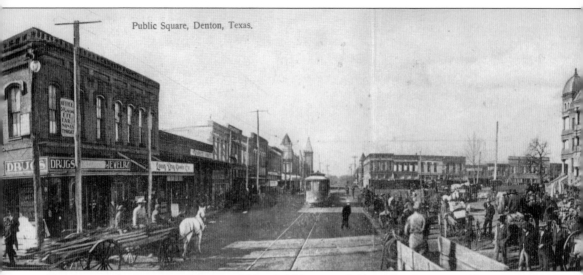

Public Square, Denton, Texas.

PANORAMA OF DENTON SQUARE. This tri-fold postcard shows the Denton public square on market day. The message on the back is the most intriguing aspect of the postcard, "Our President Taft was in Dallas Saturday night but I did not venture farther to see the gentleman. One poor man was killed on his behalf which cast a gloom all over Dallas. The crowd (so I was told) pushed him over the line, and a guard ran his bayonet through the man. He died within a few hours. He was one of Dallas' best men and was much thought of. So most of Dallas was much grieved at such an accident. Not only Dallas, but Texas, will suffer the results. Nothing will ever be done with

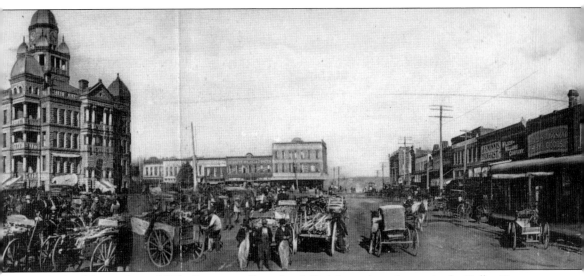

the hard-hearted guard." The "poor man" was Louis Reichenstein, a deputy in the Dallas County Clerk's office. On October 24, 1909, the *Dallas Morning News* reported that a witness, assistant fire chief Marder, observed that Reichenstein was outside the protective wire used for crowd control. Marder witnessed Texas National Guardsman J. D. Manley draw his gun, but did not see him thrust his bayonet. Reichenstein staggered back and was caught by Marder. The wound proved fatal. Manley was sentenced to life imprisonment for murder. (A.M. Simon, made in Germany, 1909.)

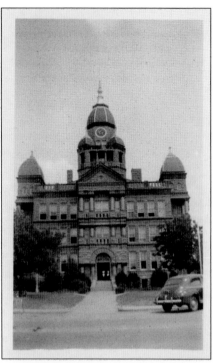

COURTHOUSE CHANGES. The courthouse in this real photograph was taken on the east side of the square. Over the years, the courthouse underwent major changes to accommodate a growing county. In 1947, the building was remodeled to meet the need for more space, and in 1949 an elevator was installed in the building's rotunda. During the 1950s and 1960s, attempts were made to modernize the building. In 1984 and 2003, restorations sought to correct the problems made over the years and return the building to its original state. (Unknown publisher, *c.* 1947.)

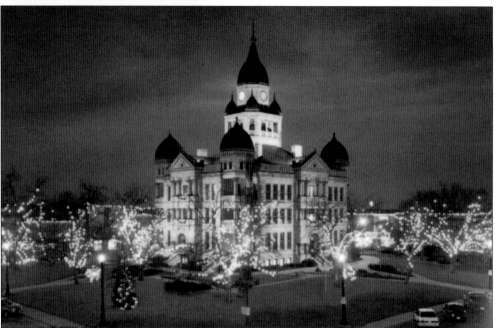

COURTHOUSE HOLIDAY LIGHTING. The Holiday Lighting Festival has been held each year since 1988 on the courthouse lawn to celebrate the Christmas season. The festival begins with a sing-a-long and the traditional lighting of the community Christmas tree. Brave Combo, Denton's Grammy award-winning band, closes this family-oriented event with a rousing concert. This postcard was produced as a fund-raising project of the Denton Holiday Festival Association. (The Photographers, Denton, *c.* 1992.)

Two

AROUND TOWN

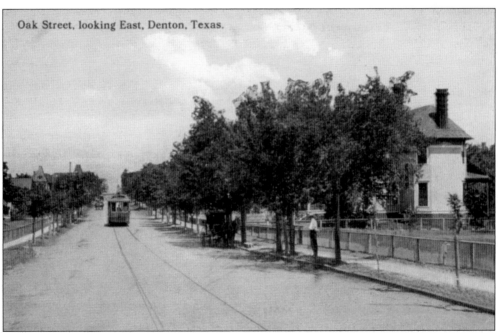

Oak Street, looking East, Denton, Texas.

OAK STREET, LOOKING EAST. By the time this tinted photographic postcard was produced, about 1915, Oak Street had established itself as the "silk stocking row" district of Denton. The street was lined with oak trees and had a fence in front of the houses. The trolley traveled toward town carrying the well-to-do Dentonites to the downtown square to shop and conduct business. The Oak-Hickory Historic District was created in 1986. (Duke and Ayres, *c.* 1915.)

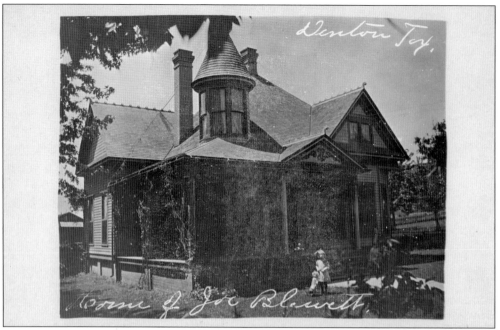

HOME OF JOE L. BLEWETT. This real photograph of an unidentified little girl posing with her baby doll in a baby carriage was taken on the front lawn of the home of Mr. and Mrs. Joe Blewett. The address of the home is a mystery, however, it is possible it was located on silk stocking row. Blewett had a meat market on the north side of the square and was on the city charter committee in 1913 and 1917. (Unknown publisher, real photo, *c.* 1917.)

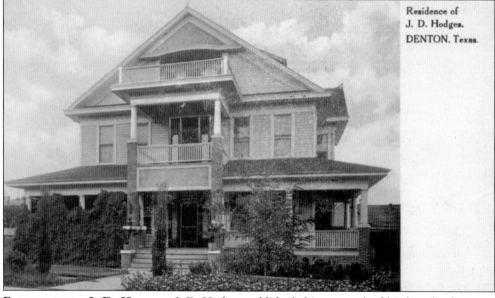

RESIDENCE OF J. D. HODGES. J. D. Hodges published this postcard of his boardinghouse at 1400 West Hickory Street to be sold in his confectionery store. Hodges operated the Hodges' Boardinghouse with his wife, Martha Ellen. This two-story, 12-room boardinghouse featured six full baths and two rooms in the attic. The house was built in 1914. (J. D. Hodges and Sons by Albertype, *c.* 1914.)

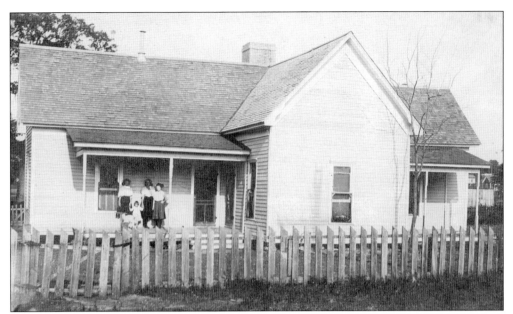

HOUSE OF C. E. FOWLER. Charles E. Fowler operated the Farmers Implement and Vehicle Company off the northeast corner of the square. He and his wife, Alice, lived in this home on South Elm Street. Pictured are, from left to right, Jessie Freeman, Willie Staples, Georgia Freeman, and Ruby Holley as identified on the back of the card. Otis Fowler, longtime director of the Denton Chamber of Commerce, was Charles Fowler's son. (Unknown publisher, real photo, *c.* 1910.)

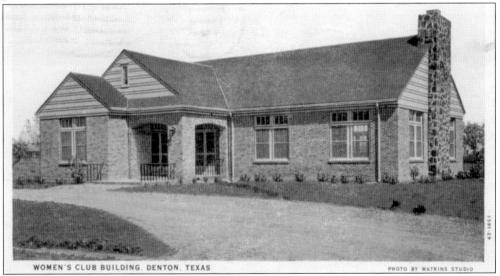

WOMEN'S CLUB BUILDING, DENTON, TEXAS PHOTO BY WATKINS STUDIO

WOMAN'S CLUB BUILDING. The City Federation of Woman's Clubs was organized in 1913. The local Ariel, Shakespeare, and several other clubs began fund-raising in 1925 for a Woman's Club Building. Architect Wiley G. Clarkson designed the building and H. F. Davidson was the contractor. Located in the city park, the building was completed in 1928. Since that time, the building has been used by the community for meetings, weddings, social gatherings, and lectures. The building was designated in 1999 as a City of Denton Historic Landmark. (Photograph by Watkins Studio by Curt Teich, *c.* 1931.)

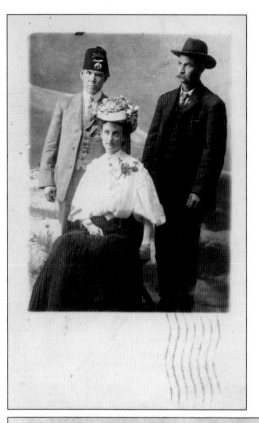

HOW DO WE THREE LOOK? It was popular for individuals to go to a studio or use their own cameras to have photographs taken to be produced into postcards. Eastman Kodak enticed people to take their photographs and send the film to Kodak for development into postcards. With the introduction of the Brownie camera, people all over the world were taking "snaps" and mailing them as postcards to friends and family. These three people are an interesting study in the art of photographic postcards. The postcard reads on the back, "How do we three look to you. Clara." This type of postcard appeals to collectors of photographic, local history, and fraternal organization postcards. (Unknown publisher, real photo, *c.* 1907.)

Dear Friend,

I am making this final effort to solicit your vote and influence in my campaign for re-election as your Sheriff. My record proves that I have given you an Honest . . . Efficient . . . and Economical administration. I would like very much to continue to be a part of the county that has been my home for 44 years. With your vote and influence, I will continue to give Denton County a clean, honest and hard-working sheriff's department. Your vote for Sheriff Ones Hodges will be appreciated more than words can tell you.

Sincerely,

Sheriff W. O. (Ones) Hodges

ONES HODGES FOR SHERIFF. W. Ones Hodges took office as Denton County Sheriff on January 1, 1949. Six days later in the line of duty he was blinded by a shotgun blast. Denton County voters reelected Hodges in 1950 and 1952. Early in the morning of December 21, 1953, Sheriff Hodges and his seeing-eye dog, Candy, were killed less than half a block from the sheriff's home. Hodges was buried in Denton with Candy at his feet. (DCM; unknown publisher, *c.* 1952.)

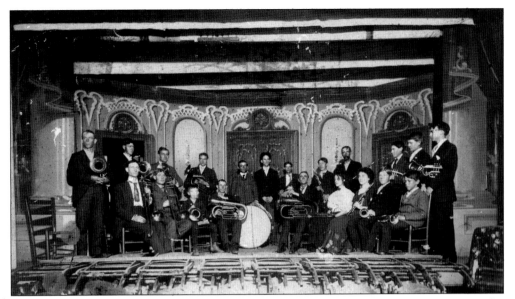

UNIDENTIFIED BAND ON STAGE. This is a mysterious postcard. Does anyone recognize this band or its musicians? The message reads, "This is our band here. Just come [sic] back home from over at Little Elm." Unfortunately the band has not been identified. Houston Bell organized the first Denton band in 1892. The band became known as the Juanita Band after one of its favorite selections, *Juanita*. Could this be the Juanita Band? (Unknown publisher, 1908.)

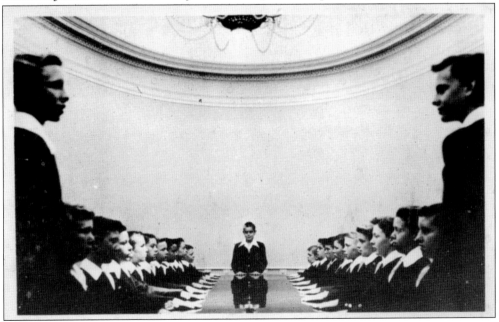

DENTON CIVIC BOY CHOIR. The Denton Civic Boy Choir started in 1946 with 37 members under the direction of George Bragg with Johnny Woods as accompanist. In 1956, the choir became known as the Texas Boys Choir of Denton. In 1957, the choir moved to Fort Worth and assumed the name Texas Boys Choir of Fort Worth. The choir still exists in Fort Worth. The back of this card brags, "This famous group has traveled 20,000 miles through 25 states and Mexico." (Hamilton Printing Company, 1950s.)

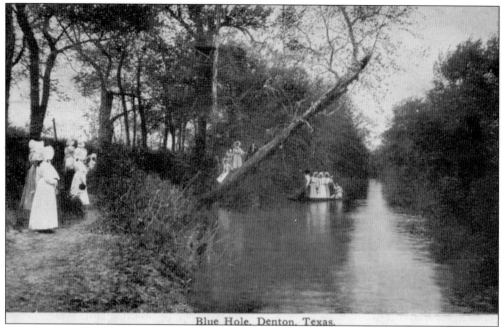

Blue Hole. Denton. Texas.

BLUE HOLE. Blue Hole, a beautiful pool of water on Hickory Creek about three quarters of a mile southwest of Denton, was a popular swimming and picnic spot. Apparently from the handwritten message on this postcard back, it may have been too popular, "There are two other girls here boarding and we waste too much time." Blue Hole was also a site for baptisms. (Unknown publisher, *c.* 1912.)

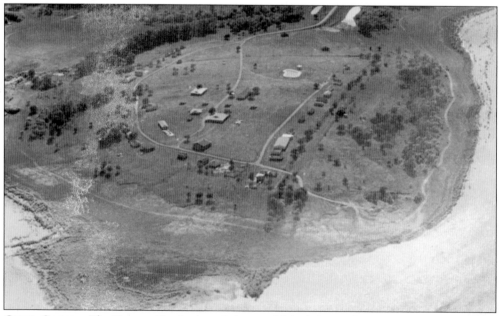

CAMP COPASS. The Denton Baptist Association established Camp Copass, a 106-acre Christian retreat center located on the west side of Lake Dallas, east of Denton, in 1946. It was named for Dr. and Mrs. B. S. Copass, who had much to do with the camp's success. Camp Copass featured guest cabins and a dining hall. (Buena Vista Airography, *c.* 1958-1963.)

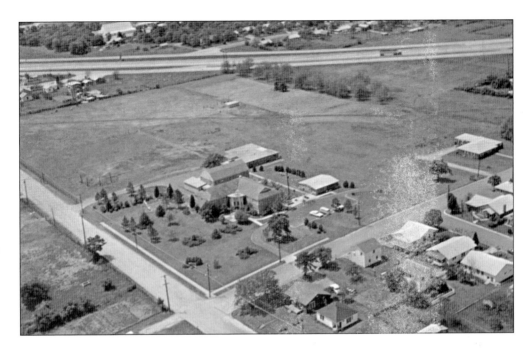

CUMBERLAND PRESBYTERIAN CHILDREN'S HOME. Established by the Cumberland Presbyterian Church denomination, the Cumberland Presbyterian Children's Home was originally chartered in Kentucky in 1904 as a home for orphaned and needy children. The children's home moved to 1304 Bernard Street in Denton in 1939 after the completion of the Old Main Building. The home receives financial support from the Cumberland Presbyterian Church and from interested individuals and groups. (Above, aerial photograph by Doug Bennett for Graphic Arts Specialties, Denton, 1960s; below, C. E. Carruth by E. C. Kropp, 1940s.)

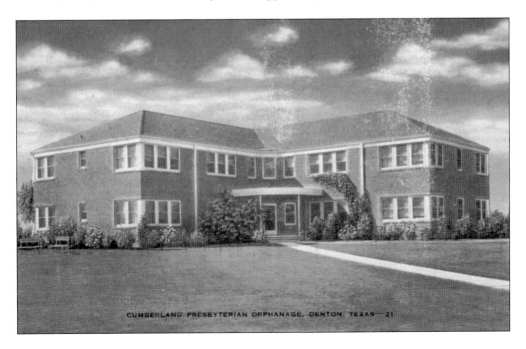

CUMBERLAND PRESBYTERIAN ORPHANAGE, DENTON, TEXAS—21

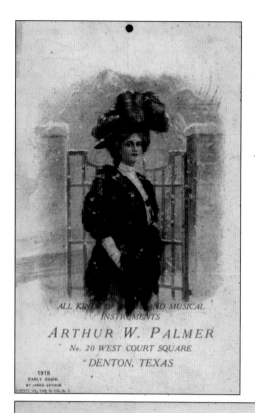

ARTHUR W. PALMER. Prof. Arthur W. Palmer, formerly a teacher at John B. Denton College, had a private music studio in the Kincaid (previously the May) Building on the north side of the square. This advertising postcard states, "All kinds of music and musical instruments." Arthur W. Palmer was located at No. 20 West Court Square in Denton. The drawing is *Early Snow* by James Arthur, copyrighted by the O. Company in 1908. (Unknown publisher, 1910.)

For You

Jimmy Clark's Chocolate Dandies

PLAYING A

DANCE

Denton Country Club

FRIDAY, APRIL 11

Nine Till One

BILLY $2.00 DENNY

JIMMY CLARK'S CHOCOLATE DANDIES. The Denton Country Club was chartered in 1922 as a men's golf club, occupying approximately 125 acres. The club closed briefly during the Depression and World War II. An additional 90-acre tract was purchased in 1970 for expansion. This postcard is announcing a dance at the Denton Country Club on Friday, April 11, 1930, featuring Jimmy Clark's Chocolate Dandies, Billy and Denny. Admission to the dance cost $2. (Unknown publisher, *c.* 1930.)

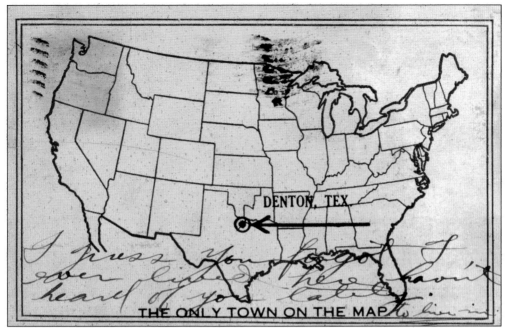

The Only Town on the Map. A popular type of tourism card was called "Texas Brags." These cards depicted the state as larger than life with exaggerated features of the flora and fauna. In typical braggadocios manner, this card shows Denton as the "only town on the map." The back of the card reads, "Everybody busy here going to school. Had a circus here last week and everybody had his fun. I imagine you are studying hard." (Unknown publisher, c. 1908.)

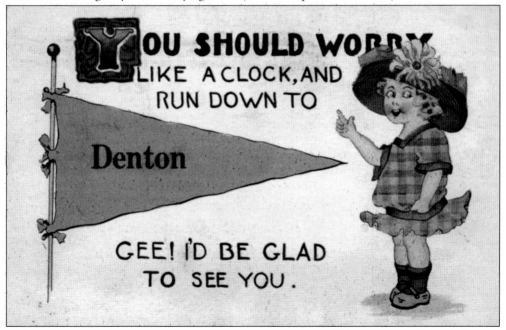

"You should worry like a clock, and run down to Denton. Gee I'd be glad to see you." The senders of this tourism postcard encouraged a Lewisville resident to come to visit them in Denton. (Unknown publisher, c. 1916.)

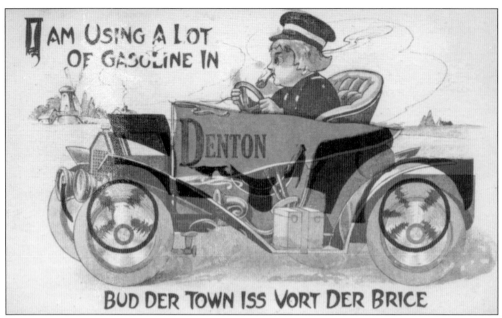

"I am Using a Lot of Gasoline in Denton." The rest of the wording on this tourism promotion postcard, "Bud Der Town Iss Vort Der Brice" is a humorous play on words. (Mfg. by BS, *c.* 1916.)

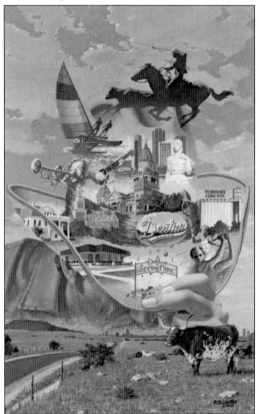

Denton Convention and Visitors Bureau. This postcard illustrates major events and landmarks depicting Denton, Texas, as "Typical Texas." Included on the postcard are music, arts, the universities, the historic courthouse, lakes, ranching, thoroughbred and quarter horses, and other tourism attractions. (Unknown publisher, *c.* 1982.)

Three

BUSINESSES

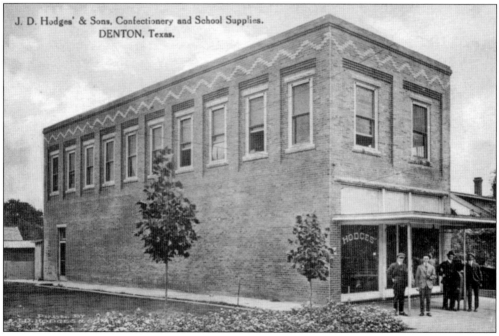

J. D. HODGES AND SONS CONFECTIONERY AND SCHOOL SUPPLIES. The J. D. Hodges and Sons Confectionery and School Supplies store was located at 1314 West Hickory Street. Hodges produced postcards of his business and his home (see previous chapter). An advertisement in his store window reads, "Student Tailor Services—Suits Pressed." Hodges sold the store to Martin and Morris in 1920. (J. D. Hodges and Sons by Albertype, *c.* 1915.)

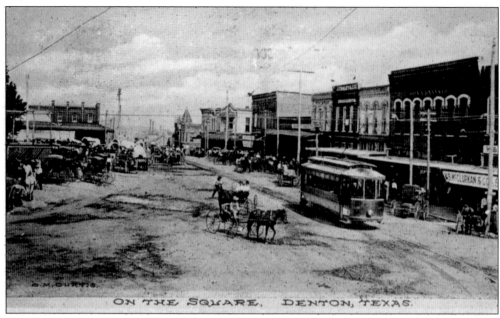

ON THE SQUARE, DENTON, TEXAS.

ON THE SQUARE SOUTH SIDE. These two postcards show the south side of the downtown business district within a 20-year time frame. The above 1908 card reflects a time when the horse and buggy was still a popular mode of transportation. The McClurkan Building, on the west end of Hickory Street, spanned four lots. Other businesses were J. A. Hann, J. F. Raley Druggist, and Evers Hardware. In 1907, the Denton Traction Company installed the track that traversed the entire square. Service was discontinued in 1918. The postcard below shows the developments that were made by 1926, including paved streets, the Confederate Monument, electric lights, and O. M. Curtis Drugs located in the Raley Building. (Above, O. M. Curtis, 1908; below, O. M. Curtis by Albertype, 1926.)

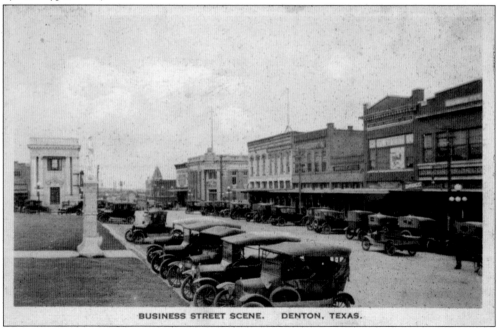

BUSINESS STREET SCENE. DENTON, TEXAS.

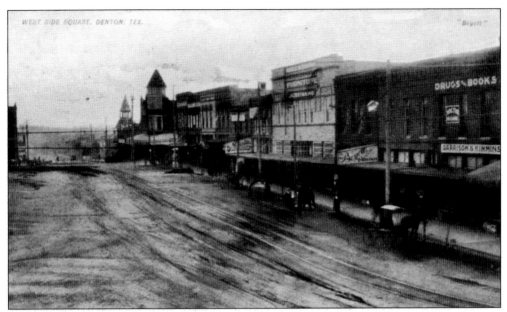

WEST SIDE SQUARE 1909. This postcard shows the Elm Street businesses that were downtown in 1909, including Garrison and Kimmins Drugs, Beyette store, and McGill and Shephard Furniture and Undertaking. At the southwest corner of the square was the Donahower Block, which burned in 1914, destroying the archives of the *Record* and the *Chronicle* newspapers. (Beyette by Bradford and Co., 1909.)

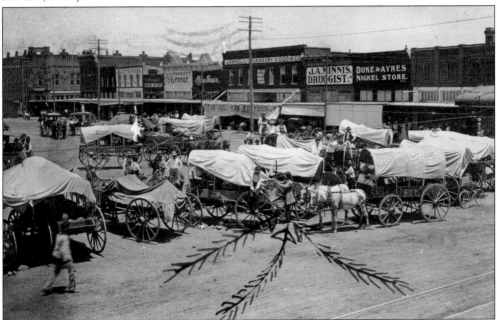

EAST SIDE SQUARE 1910. Businesses on the east side of the square in 1910 included the Wright Opera House, Paschall Building, Julian Scruggs Dry Goods, L. L. Puckett Grocery Store, the Fair, Jarrell-Evans Dry Goods, J. A. Minnis Druggist, the Williams Store, and Duke and Ayres Nickel Store. Duke and Ayres was probably the first of the present-day chain stores in Denton. (Unknown publisher, real photo, 1910.)

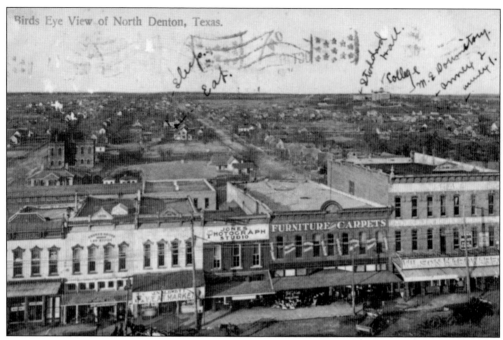

BIRD'S-EYE VIEW OF NORTH SIDE OF SQUARE. Some subtle differences in the businesses appear in these two postcards, which date just two years apart. The above postcard shows the businesses on the square in 1909, including First National Bank, Emory C. Smith's Law Office, J. N. Blewett Meat Market, Jones Photograph Studio, Schmitz Furniture and Undertaking, Shaw's Photography, and Wilson Hardware. The College of Industrial Arts is in the background in the top right corner. The postcard below shows many of the same businesses. The exception is that the White Photography Studio that replaced Jones and Egan Land Company was in the May Building. (Above, A. M. Simon, made in Germany, 1909; below, Duke and Ayres Company, 1911.)

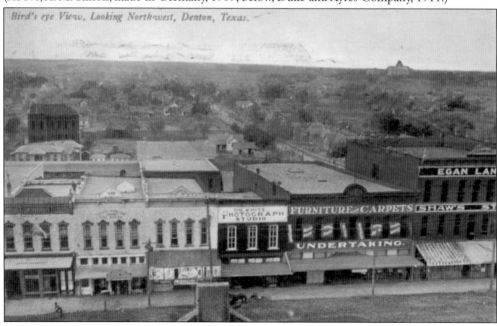

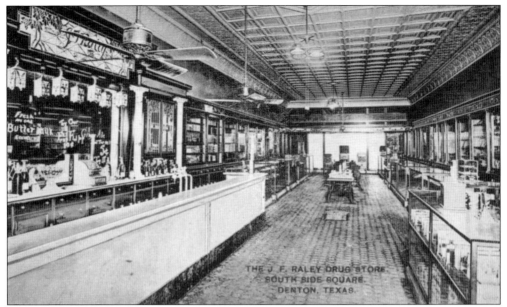

THE J. F. RALEY DRUG STORE, SOUTH SIDE SQUARE. The Raley Building, constructed in 1885, was located in the middle of the block on the south side of the square at 111 West Hickory. James F. Raley operated his drugstore at that location until he sold it to O. M. Curtis in May 1918. Curtis moved both of his stores to the Raley Building in April 1919. Others tenants in the Raley Building were attorneys, Tede Ponder Men's Dry Goods Store, and later Dr. Norwood F. Moore's optometry business. The Raley Building burned in 1972. (Albertype, pre-1918.)

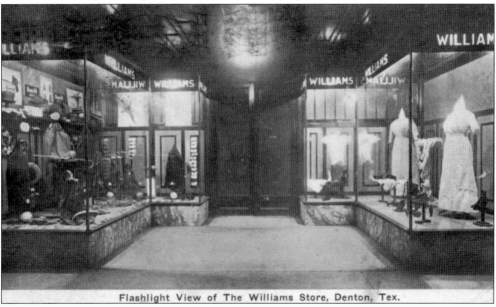

FLASHLIGHT VIEW OF THE WILLIAMS STORE. Originally opened by C. Alex Williams, the Williams Dry Goods Store conducted business on the downtown square for almost 100 years. Upon his death, management of the store passed to his son Will Williams. The store was closed in 1956. The message reads on the back, "This is the store where Loran works. Mrs. Richardson." (E. C. Kropp, *c.* 1913.)

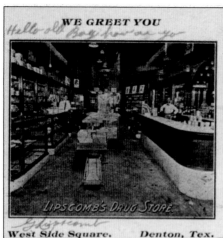

When in Denton

—Call On Us For—

DRUGS AND DRUG SUNDRIES, JEWELRY TABLETS, PENCILS, PENS, INKS, CIGARS, TOBACCO, LEDGERS AND DAY BOOKS, AND NOTE PAPER.

Visit Our Soda Fountain

Prescription Work a Specialty

We Are Always Glad to See —YOU—

LIPSCOMB DRUG STORE. The note on the front of this postcard reads, "Hello old boy, how are you" and is signed, "G. Lipscomb." Legrand Lipscomb's store, located on the west side of the square at 107 North Elm Street, sold drugs and sundries, jewelry, tablets, pencils, pens, inks, cigars, tobacco, ledgers, daybooks, and notepaper and featured a soda fountain. (Unknown publisher, *c.* 1913.)

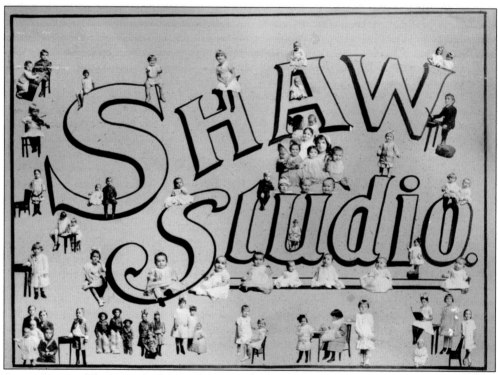

SHAW STUDIO. The Shaw Studio was located at 117 North Elm Street and later at 206 West Oak Street. After a mistake was made on an order, this message was sent to Tullie Sullivan, CIA, City [Denton], "By mistake your photos have been put in the wrong folders but I am sending them anyway without extra charge though they are higher priced than the cards you ordered. Will change them if you desire it. Very truly yours, J. W. Shaw." Shaw often used collages of children to advertise his studio. (Shaw Studio, 1915.)

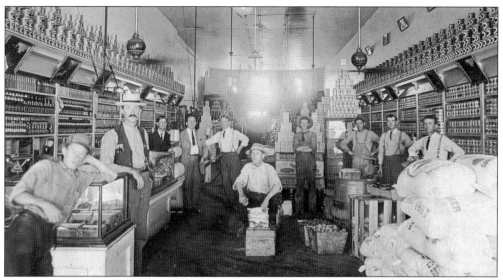

L. L. Puckett Grocery Store. In 1920, there were 18 grocery stores within five blocks of the downtown square. The L. L. Puckett Grocery Store was located at 114 North Locust Street. Featured in this real photograph postcard of the store are, from left to right, Edgar Davidson, unidentified drummer, Boss Taylor, unidentified drummer, Dee Puckett, Will Taylor (seated in center), Hugh Skiles, Jack Skiles, Pat Gallagher, and Jack Jones (Will Taylor's brother-in-law). (DCM; unknown publisher, *c.* 1919.)

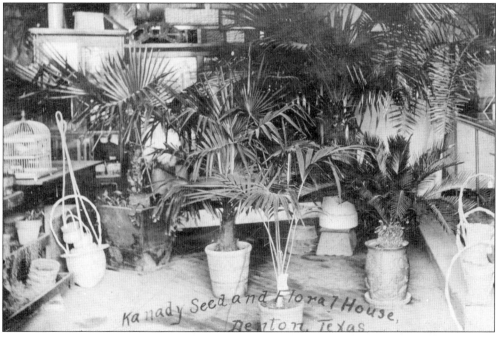

Kanady (Kanaday) Seed and Floral House. In 1916, S. Wallace Kanaday operated a seed and general merchandise store and Denton Floral Company at 214 West Oak Street. Kanaday also owned a saddle shop at 216 West Oak Street and advertised in the 1920 city directory that they had been in business for 25 years selling saddles and harnesses. The seed and floral business burned in 1926. (Unknown publisher, 1920.)

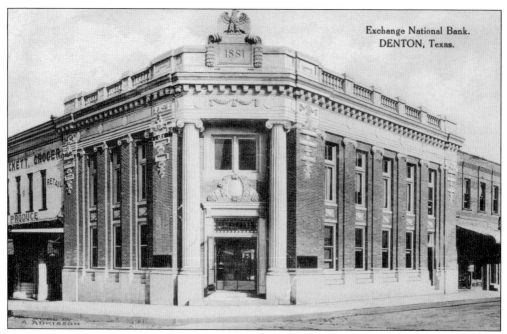

EXCHANGE NATIONAL BANK. The first Denton bank opened in 1870 in the law office of Joseph A. Carroll and James M. Daugherty on the southeast corner of the square. In 1881, it became Exchange National Bank. In 1913, Exchange National Bank constructed a new building across Hickory Street from Denton County National Bank. The officers were J. R. Christal, president; Ed F. Bates, vice president; and J. C. Coit, cashier. Capital and surplus in 1920 totaled $150,000. Exchange National Bank failed in 1928. (Albertype, *c.* 1913–1928.)

NEW HOME OF FIRST STATE BANK. First State Bank took over the southeast corner location on the square in April 1931. A new building was constructed on this site in 1961 and expanded in 1972. It is now home to Wells Fargo Bank. (Unknown publisher, 1961.)

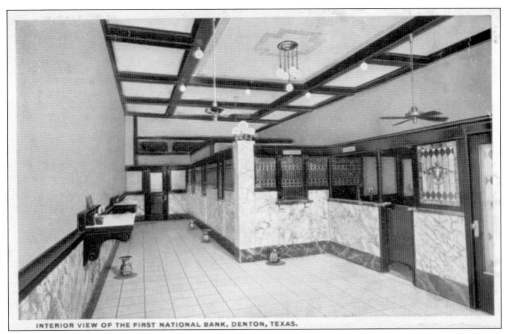

INTERIOR VIEW OF THE FIRST NATIONAL BANK, DENTON, TEXAS.

INTERIOR VIEW OF FIRST NATIONAL BANK. Around 1880, D. A. Robinson and Tillie Trimble started a private bank, the Robinson and Trimble Bank. First National Bank was organized out of that bank with $100,000 capitalization. It was forced to close in 1928 under questionable circumstances. (Curt Teich, *c.* 1912–1924.)

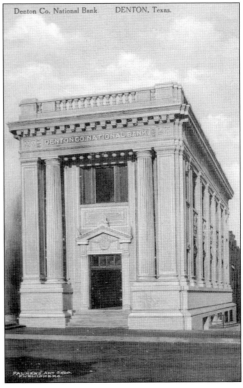

DENTON COUNTY NATIONAL BANK. Thirty-one city leaders organized Denton County National Bank in 1892. In 1913, the bank constructed a new building at 100 North Locust Street. W. B. McClurkan was president in 1920. Denton County National Bank moved in 1962 to Hickory Street and is now the offices for Denton Area Teachers Credit Union. The building's landmark clock was not added to the bank exterior until 1917. (Designed by Palmer's Art Shop by Albertype, *c.* 1913–1916.)

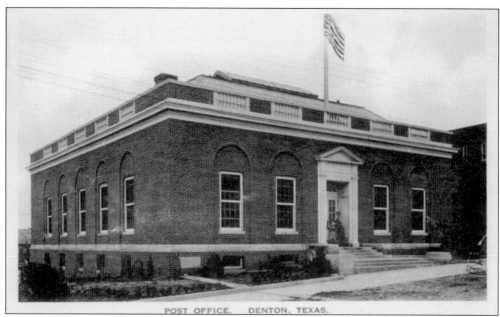

POST OFFICE. DENTON, TEXAS.

POST OFFICE. This postcard is of the Denton Post Office at 210 North Locust Street, which served the public for 55 years until a new post office was constructed on East McKinney Street in 1975. Jess Rowlett, a postal employee for 33 years, delivered mail after World War II by walking his route. He recalled one carrier who drove a Model A Ford truck to deliver parcels. (O. M. Curtis by Albertype, 1950s.)

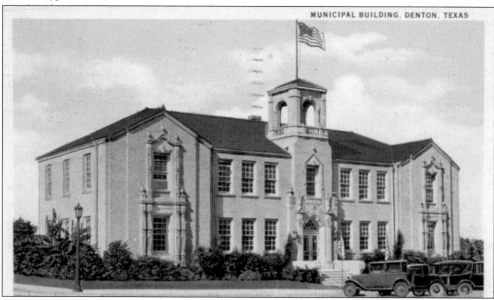

MUNICIPAL BUILDING, DENTON, TEXAS

MUNICIPAL BUILDING. Gov. Dan Moody dedicated Denton City Hall at 221 North Elm Street, on October 8, 1927. This Spanish Renaissance building was the seat of city government, with a large auditorium, and the fire department in the basement. Many city offices moved in 1967 when the new city hall was built. This card was purchased in Denton and mailed in Abilene while the traveler drove through Texas. "Nothing but sand and cactus between here [Abilene] and El Paso." (C. E. Carruth by Curt Teich, 1934.)

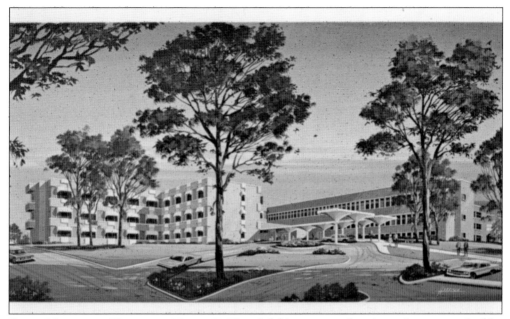

FLOW MEMORIAL HOSPITAL. Homer E. Flow left his estate to the city and county to build a public hospital. Land on Scripture Hill was purchased, and on September 3, 1950, the three-story brick, 60-bed hospital was opened. Mrs. J. F. Raley left money from her estate to the hospital that provided the seed money for the new wing that was completed in the 1960s. Flow Memorial closed as a public hospital in 1988 and was torn down in 2002. (DCM; Hospital Publications by Dexter Press, 1960s.)

WESTGATE HOSPITAL AND MEDICAL CENTER. Westgate Hospital and Medical Center, a 130-bed private hospital, opened on December 30, 1973, at 4405 North Interstate 35. The hospital was organized by a group of local doctors. It was purchased by HCA Columbia, and the new facility opened in 1999 as Denton Regional Medical Center. (Hospital Publications by Dexter Press, 1970s.)

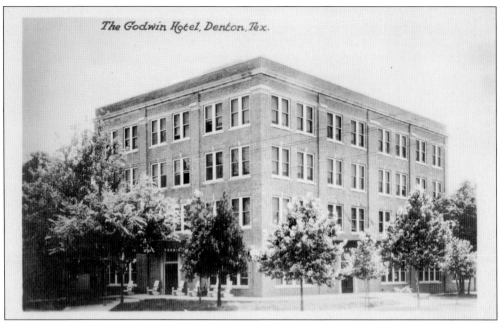

THE GODWIN HOTEL. Claude Godwin opened a 28-room hotel at the corner of South Elm and Sycamore Streets in 1925. Two years later, he opened the 60-room Godwin Hotel next door to his smaller hotel. A 1929 advertisement in the Denton city directory reads, "Modern Fireproof Sanitary. The Traveling Man's Home. Home People Always Welcome." (Photo and Art Postal Card Company, *c.* 1926–1931.)

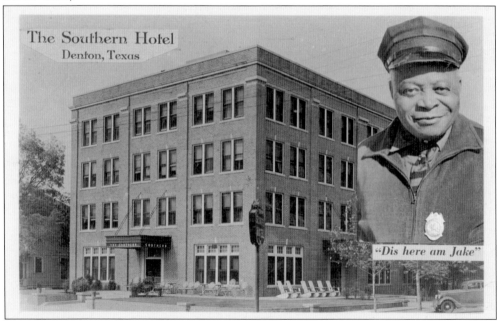

THE SOUTHERN HOTEL. The Rayzor brothers purchased the Godwin Hotel in 1931 and changed its name to the Southern Hotel with Fred Cobb as manager. It operated until 1960. It currently serves as low-income elderly housing. This card features Jake Huey, a porter and well-known fixture at the hotel for many years. (Unknown publisher, *c.* 1935.)

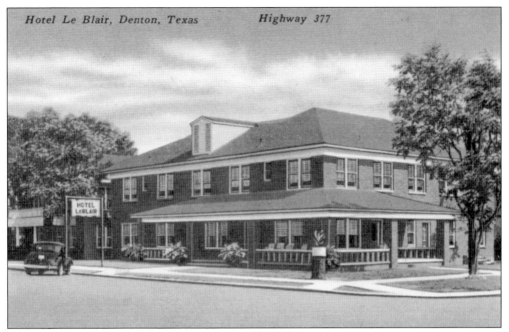

HOTEL LEBLAIR. The Hotel LeBlair opened in 1935 when Dr. A. B. Krout purchased the 28-room hotel from Claude Godwin. This postcard advertises the Hotel LeBlair as being "air conditioned, cool, clean, redecorated, with sanitary rooms and comfortable beds, friendly service." It was located at 119 West Sycamore Street. The hotel closed in 1963. (C. E. Carruth by Nationwide Advertising Specialty Company, *c.* 1939.)

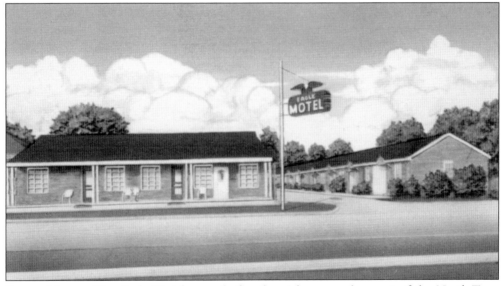

EAGLE MOTEL. The Eagle Motel, named after the nickname and mascot of the North Texas State Normal College athletic teams, the Eagles, opened in 1939 and boasted refrigerated, air-conditioned rooms, room telephones, tile baths, and vented heat. Located five blocks south of the courthouse square at 600 South Elm and 600 South Locust Streets, the motel was conveniently located near both universities. Owner W. E. (Eddie) Williams closed the hotel in 1973. (Nationwide Post Card Company, *c.* 1950.)

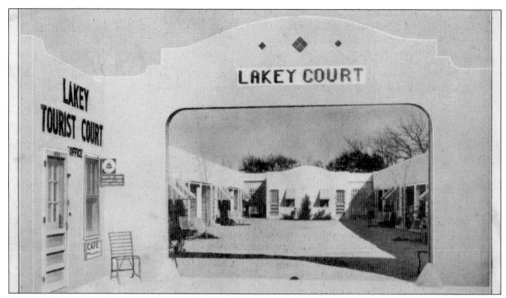

LAKEY TOURIST COURT. This is a rare tri-folded advertisement postcard featuring the Lakey Tourist Court, built in 1930 at 502–504 North Locust Street. The tourist court provided travelers with overnight accommodations with covered parking. Offering 24-hour service, the tourist court featured a cafe, rooms with a kitchen, barbershop, and the Sam Laney Service Station. (Unknown publisher, *c.* 1936.)

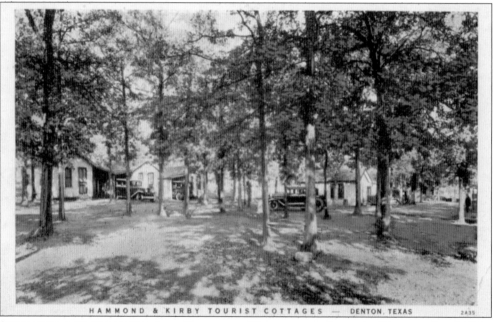

HAMMOND & KIRBY TOURIST COTTAGES — DENTON, TEXAS

HAMMOND AND KIRBY TOURIST COTTAGES. This postcard shows the Hammond and Kirby Tourist Cottages at 903 South Locust Street that were built in 1938. The text on the back reads, "Every cottage a private home. Located 6 blocks south of courthouse on Highways 10, 24, 40 and 77. Fifteen individual cottages completely furnished and equipped with gas and electric light. Hot and cold showers available. A house for every size family; a price for every size purse." (Unknown publisher, 1930s.)

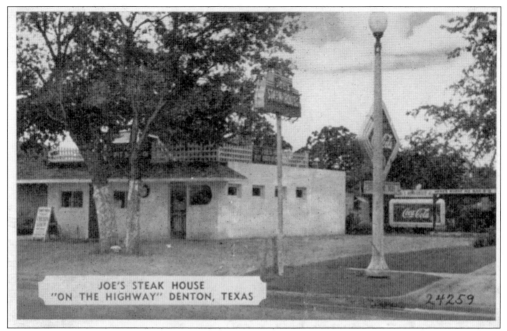

JOE'S STEAK HOUSE. Joe's Pit Bar-B-Q stand was located at 516 South Locust Street from 1933 until 1944; Joe Wankan was the manager. It became the Steak House in 1945 and advertised itself as "the place that's famous from Coast to Coast for Joe's Steak Plate and Manny's Plantation Plate." (Kaeser and Blair, *c.* 1933–1944.)

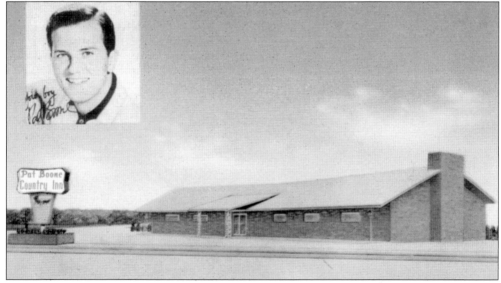

PAT BOONE COUNTRY INN. In the corner of this postcard of the short-lived restaurant venture that Pat Boone owned with his partner, M. T. Klein, is a photograph of young Pat Boone signed, "Your boy, Pat Boone." Pat Boone came to Denton in 1955 to study music at North Texas. After leaving Denton in 1956, he continued a singing and movie career. By 1957, Pat Boone became a popular movie and television star. In 1958, he opened a restaurant called Pat Boone Country Inn that featured "fine food and a pleasing atmosphere." The inn closed in 1962. (M & B Specialty Company, *c.* 1958.)

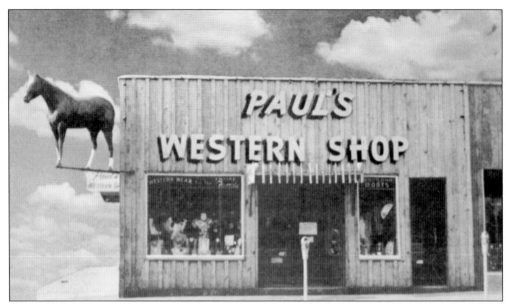

PAUL'S WESTERN SHOP. Paul Gallo sold Western wear, saddles, and tack at his store at 101 West Hickory Street. His slogan was "Specializing in Western wear for the entire family!" He operated his shop from 1953 until 1972 under "Levi," the big red horse. In 1974, Gallo and Levi moved to 104 North Locust Street. Several other nationally known Western shops still operate in Denton County: Weldon's Saddle Shop, Justin Boots and Cowboy Outfitters, Smith Brothers, and Foster's Western Wear and Saddle Shop. (Unknown publisher, *c.* 1965.)

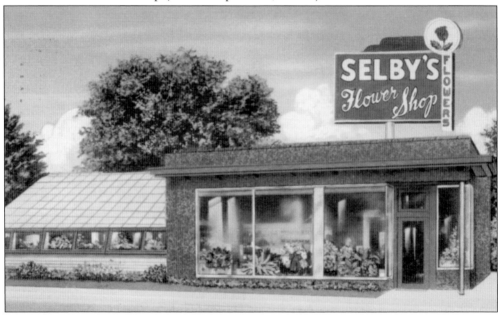

SELBY'S FLOWER SHOP. In 1910, R. L. Selby Sr. started what became one of the largest nursery and greenhouse businesses in this county. It was located at 1400 South Locust Street. R. L. Selby Jr. and his wife, Lewis Marie, operated a flower shop at North Locust Street from 1943 until 1977, selling roses, gladiolas, and other flowers from the greenhouses. The North Locust Street flower shop is now home to a restaurant named the GreenHouse. (Nationwide Post Card, 1958.)

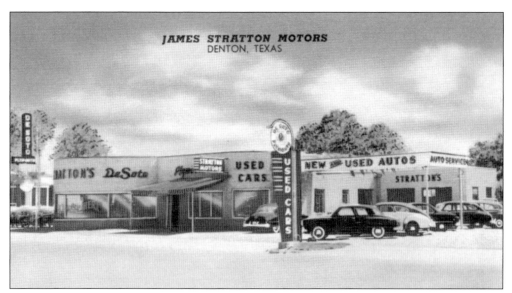

JAMES STRATTON MOTORS. Stratton Motors opened in 1947 at 417 South Locust Street to sell De Soto and Plymouth automobiles. The Stratton showroom could display six cars. Due to the war, only two new De Sotos and one Plymouth could be at the grand opening for prospective car purchasers to order. The automobile dealership closed in 1952. (Nationwide Specialty Company, *c.* 1947–1952.)

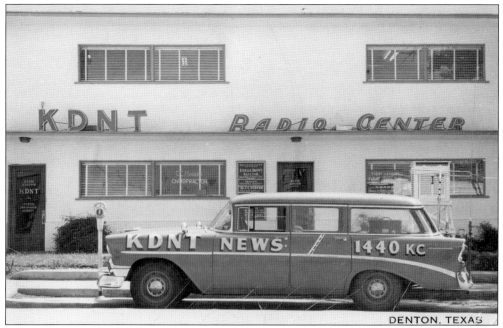

KDNT RADIO CENTER. Harwell V. Shepard started the KDNT/1440 radio station with $6,000 in 1938 in a two-story building on a lot for which he paid $5 at the corner of Ross and Denison Streets. By the 1950s, transmissions were being made from the station's new location at 235 West Hickory Street, the Radio Center. The station had captured 52 percent of the area listening audience and was touted as the "most listened to" station. Mel Wheeler purchased the station in 1972 and moved it to Teasley Lane. (Unknown publisher, real photo, *c.* 1956.)

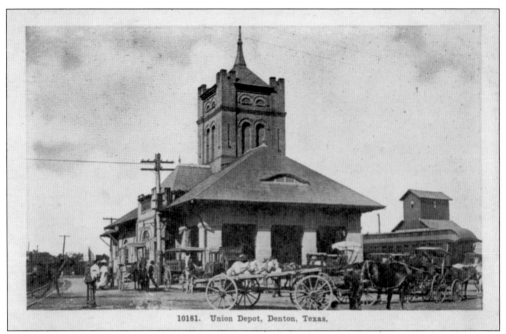

10181. Union Depot, Denton, Texas.

UNION DEPOT. The Texas and Pacific Railroad reached Denton on April 1, 1881, ushering in a new era for economic development. Built in 1900, the depot served passengers on the Texas and Pacific and Missouri, Kansas, and Texas (Katy) Railways. The message on the back of the above postcard was written in German and sent to Bremen, Germany, "Dear Marianne, Have forgotten to write a card to you. Hope when you go to school that I may then come in summer to Germany, and bring your Aunt Ana with me. Sincerely, Your Uncle Hans." (Above, unknown publisher, 1910; below, E. C. Kropp, *c.* 1910.)

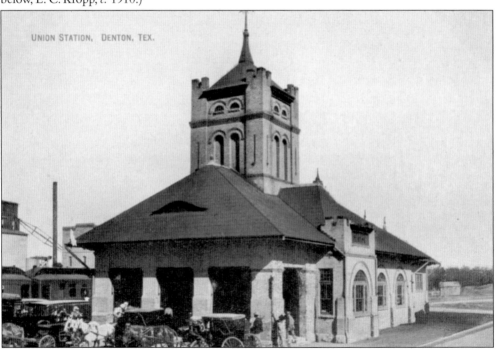

UNION STATION, DENTON, TEX.

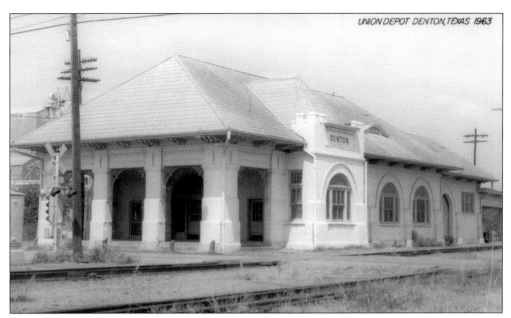

UNION DEPOT WITHOUT THE TOWER. In 1948, the Union Depot underwent an extensive renovation when the tower was removed and murals by Irene and Seymour Grady covered the walls. The murals depicted Denton County scenes, including the courthouse, the city park, various local businesses, and the fairground. To the left of the arched waiting-room entrance was a painting of Texas State College for Women and on the right was North Texas State College. Texas and Pacific passenger service was discontinued in July 1950; the last Katy passenger train ran in December 1958. The depot was razed in 1964. (Unknown publisher, real photo, 1963.)

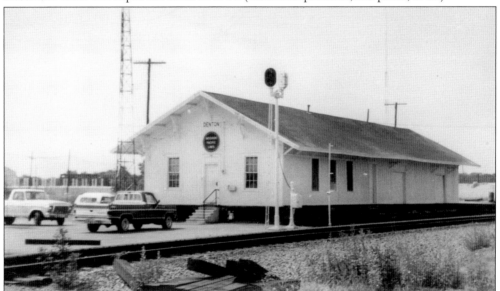

MISSOURI–PACIFIC FREIGHT DEPOT. The Missouri-Pacific Freight Depot was built in 1881 on East Hickory Street by Texas and Pacific for all freight service in Denton. The station continued operating even after passenger service was discontinued in the 1960s. The Missouri-Pacific Railroad closed the office in 1983. After falling into disrepair, and despite efforts to save it, the building was torn down in 1999. (Unknown publisher, real photo, 1979.)

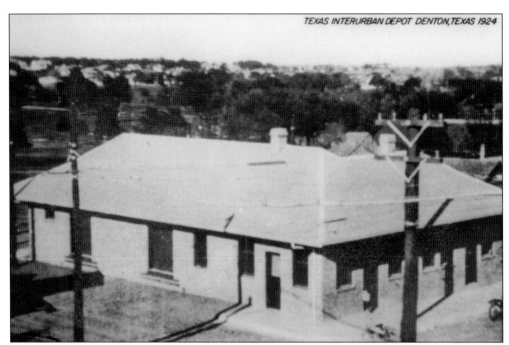

TEXAS INTERURBAN DEPOT. The Texas Interurban Railway was built to ease commuting between Denton and Dallas. Beginning in 1924, the interurban traveled along the tracks of the Missouri, Kansas, and Texas Railroad. The Denton substation was located at McKinney at Ash (now Austin) Streets. But with the popularity of the automobile, train service ended in the early 1930s. Seventy years later, Denton is bringing back train transportation between Denton and Dallas with the A-Train connecting Denton and Carrollton. (Unknown publisher, real photo, 1924.)

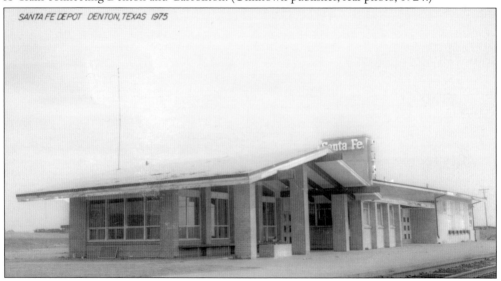

SANTA FE DEPOT DENTON, TEXAS 1975

SANTA FE DEPOT. After 70 years of campaigning to acquire a third major railway line, the city welcomed the first train of the Santa Fe Railroad to Denton on December 5, 1955. The Santa Fe station was located near North Texas State College on the Dallas Highway. The last Santa Fe train, the last passenger train to stop in Denton, left the station on July 19, 1968. Freight service was discontinued in 1982. (Unknown publisher, 1975.)

Four

CHURCHES

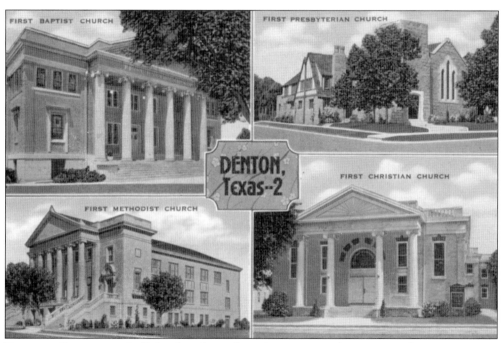

DENTON CHURCHES. Religion has always been important to the citizens of Denton County. The first church services were often held in the courthouse and Masonic Lodge. The Methodist, Baptist, Presbyterian, and Christian congregations were the first to establish churches. By the time of the publication of this postcard, the congregations of the city of Denton were represented by 14 different religious denominations with memberships running into the thousands. (C. E. Carruth, E. C. Kropp, *c.* 1934.)

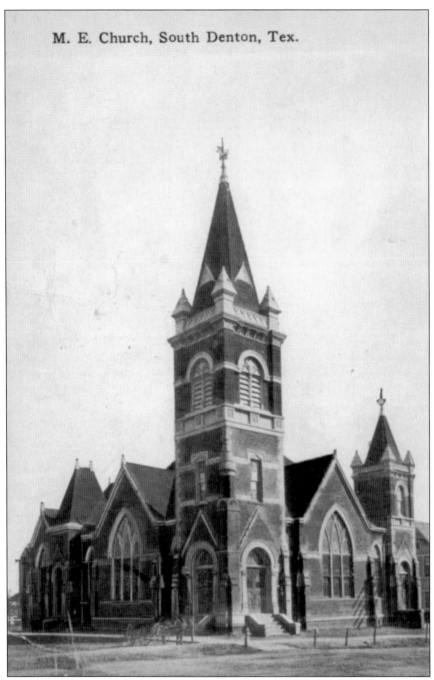

M. E. Church, South Denton, Tex.

M. E. CHURCH, SOUTH. The Methodists were the first to organize a congregation in Denton. Circuit rider William E. Bates established the church in the fall 1857. A white frame church was built at 201 South Locust Street in 1872 and served the congregation until it was moved in 1898. The following summer, a second church was built at the same location. This Gothic-style building was redbrick veneer with white trim. Since it was built before the establishment of the two colleges, the congregation soon outgrew the building. The church was razed on January 11, 1923. (E. C. Kropp, *c.* 1910–1911.)

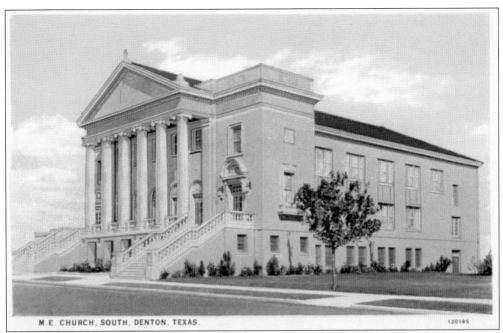

M.E. CHURCH, SOUTH, DENTON, TEXAS.

120195

FIRST METHODIST CHURCH WITH AND WITHOUT COLE CHAPEL. In 1923, the congregation of the First Methodist Church of Denton began a pay-as-you-go campaign to build a new church facility. The church had acquired no debt when members dedicated the building on March 1, 1925. They also purchased the remainder of the block facing South Locust Street and built a parsonage. Additions in 1951 included Cole Chapel, a student center, and a three-story education building. In 1956, the church boasted a congregation of approximately 2,000 members with an additional 1,500 students from the two colleges. (Above, Curt Teich, *c.* 1925–1951; below, Curt Teich, *c.* 1956.)

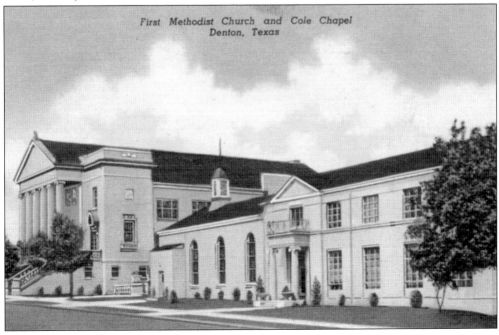

First Methodist Church and Cole Chapel
Denton, Texas

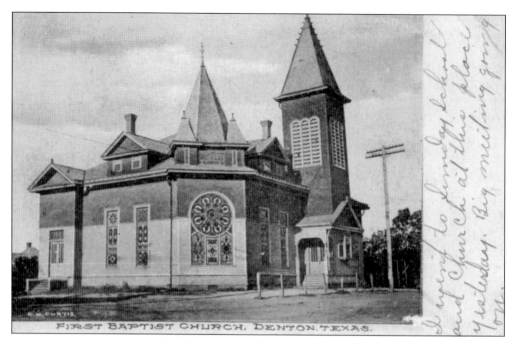

FIRST BAPTIST CHURCH, DENTON, TEXAS.

FIRST BAPTIST CHURCH. The First Baptist Church of Denton was organized in spring 1858. The first church was built at the corner of Hickory and Cedar Streets in spring 1876. The church was a white-frame building with a modest steeple. In 1897, this building was torn down, and a new church was built on the site facing Hickory Street. This new frame church, pictured above, featured a bottom portion painted light green and top of wine with a green roof. It burned on March 3, 1917. The congregation dedicated a new brick building fronted with Greek columns on West Oak Street in September 1918. (Above, O. M. Curtis, 1910; below, O. M. Curtis by Albertype, 1922.)

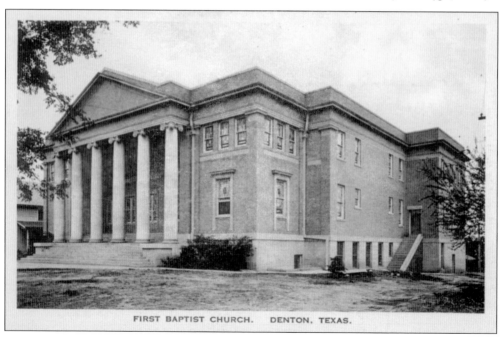

FIRST BAPTIST CHURCH. DENTON, TEXAS.

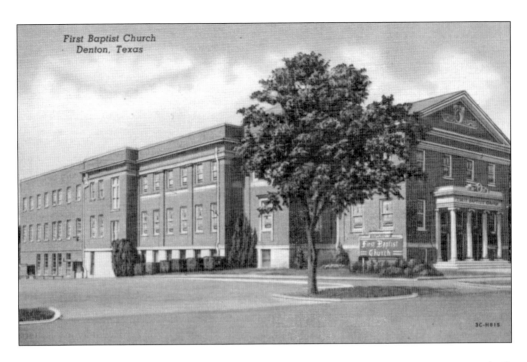

First Baptist Church
Denton, Texas

ANOTHER FIRST BAPTIST CHURCH. The First Baptist Church on West Oak Street was built in 1918 during a time when steel was unavailable due to World War I. The building experienced many structural problems and underwent extensive renovations from 1931 to 1934, including changes made to the exterior. In 1961, the growing congregation purchased property on Malone Street, and construction began on the current building in 1966. The first services were held on December 10, 1967. (Above, Fultz News Agency by Curt Teich, *c.* 1950; below, Burchard's Studio, *c.* 1970.)

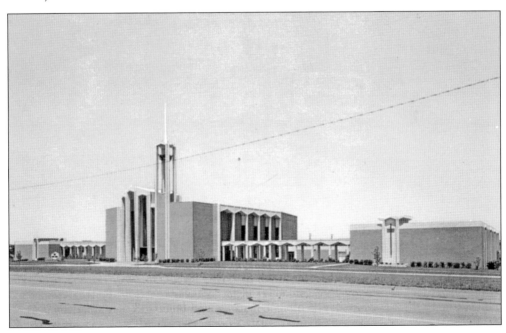

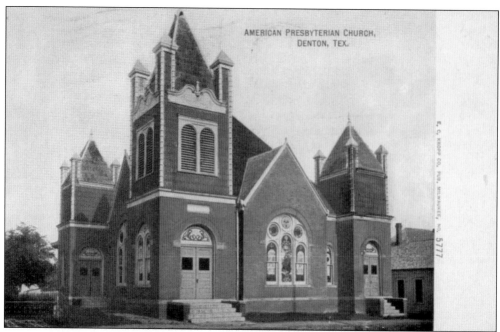

ST. ANDREW PRESBYTERIAN CHURCH. The Cumberland Presbyterian Church was established in 1862. This congregation was the first to build a structure in 1871, and many other churches met in the building. That building burned in 1875, along with many county records. A white wooden church was built on Bolivar Street in 1876 followed by a brick building in 1901. The current lot at West Oak and Bolivar Streets was purchased in 1925, and the first services were held in the new church in 1942. The church changed names five times in the course of its history. It became American Presbyterian in 1906; Central Presbyterian in 1910; First Presbyterian Church, USA in 1939; and finally St. Andrew Presbyterian Church in 1959. (Above, E. C. Kropp, 1909; below, Fultz News Agency by Curt Teich, *c.* 1942–1958.)

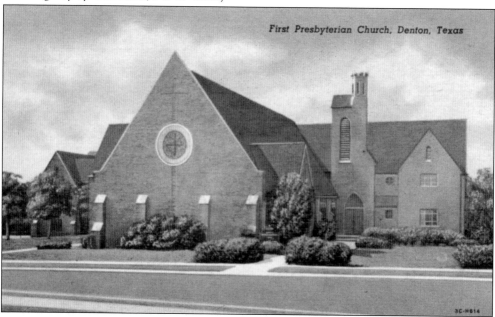

52

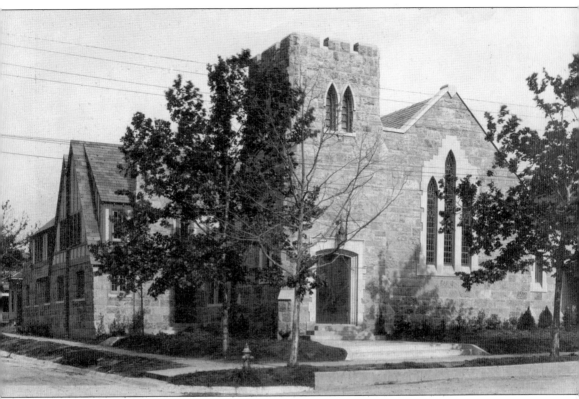

PRESBYTERIAN CHURCH. The First Presbyterian Church of Denton was organized on May 2, 1878, with 14 members. Services were held in various locations until the first church was built in 1884 on South Elm Street. This building was razed in 1925, and a new building, pictured here and known as the Rock Church, was completed in 1926. The church was in the English style and made of rough-cut Leuter stone. The congregation moved to the corner of University and Hinkle Drives in 1965. (Unknown publisher, real photo, *c.* 1930.)

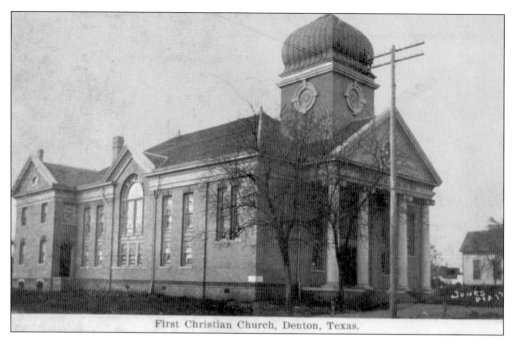

First Christian Church, Denton, Texas.

FIRST CHRISTIAN CHURCH. The First Christian Church of Denton was organized on May 27, 1868, and met in the Masonic Lodge until the first building was constructed in 1876 on North Elm Street. The church was later moved to West Hickory Street. On November 20, 1904, a modern brick building located on Piner and Hickory Streets was dedicated. The structure underwent various renovations until it was declared unsafe and torn down in 1939. These images reflect the brick church before and after renovations. A frame building served as the church home until 1959. (Above, R. Taliaferro Jones, RPO, 1909; below, O. M. Curtis by Albertype, 1932.)

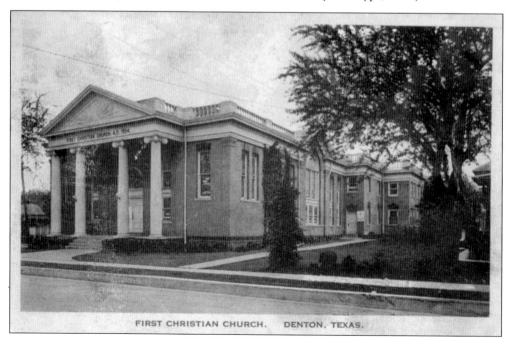

FIRST CHRISTIAN CHURCH. DENTON, TEXAS.

FIRST CHRISTIAN CHURCH. In 1956, the First Christian Church purchased property on Fulton Street. The current building was designed by noted architect O'Neil Ford and completed in 1959. The unique concrete roof is a hyperbolic paraboloid supported by the foundation and 10 columns rather than walls. The five columns on each side represent hands lifted in prayer, while the ridges and valleys of the roof symbolize hands folded in prayer. (Burchard's Studio, 1960s.)

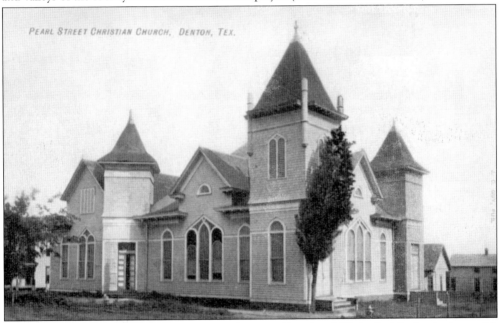

PEARL STREET CHRISTIAN CHURCH. Pearl Street Church of Christ had its beginnings with the First Christian Church. In 1893, a dispute over the use of organ music and the selection of a new pastor caused the "anti-organ" group to move to Pearl Street. In 1905, this church moved to the corner of Pearl and Bolivar Streets. The building was enlarged around 1912. A new building was constructed in 1951. The congregation moved to a new facility in 2007 and is now known as Sherman Drive Church of Christ. (MC; J. C. Guy Publishers, 1912.)

IMMACULATE CONCEPTION CATHOLIC CHURCH. The first Catholic congregation met in a two-story barn in 1890. In 1893–1894, a parish was built at Second and Bolivar Streets. Father F. X. Meilinger, the parish priest, helped with the carpentry work. This building was torn down in 1956 and replaced by the new Immaculate Conception Catholic Church at the corner of Second and Elm Streets. The new building could seat 400 parishioners. A parish center was completed in 1966. The congregation moved to a new facility on Bonnie Brae in 2004. (Burchard's Studio, 1960s.)

GRACE TEMPLE BAPTIST CHURCH. Grace Temple Baptist Church was founded on March 6, 1949. A chapel, pictured here, was built the following year at 1106 West Oak Street near North Texas State College. A new sanctuary and auditorium were completed in October 1982. The church hosts an annual Thanksgiving dinner each year for college students, a practice that has continued after the church merged with the Village Church in 2007. (MWM Company, c. 1961.)

Five

PUBLIC SCHOOLS

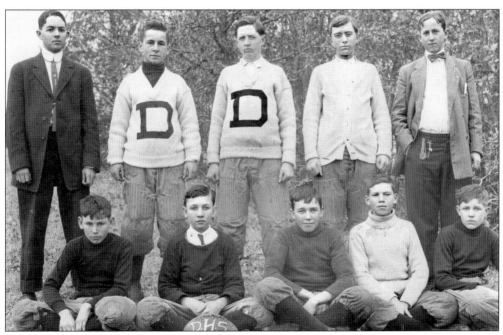

THE THIRD DENTON HIGH SCHOOL FOOTBALL TEAM. Denton High School developed a tradition for sports as early as 1910 with the creation of a football team. The high school boys competed with schools mainly from Dallas. The unidentified young men in this real photograph postcard are described as "the third football team of Denton." It was sent from Douglas Witt, grandson of Mr. and Mrs. W. E. Bates of Canyon, Texas. (Unknown publisher, real photo, 1912.)

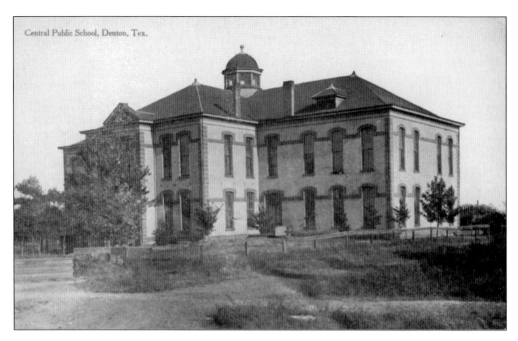

Central Public School, Denton, Tex.

CENTRAL PUBLIC SCHOOL AND RUINS OF HIGH SCHOOL. The first free public school opened in Denton in April 1884 for a four-month session. The building was a three-story brick structure located on East McKinney Street. It housed all grades until 1899 when the North Ward Elementary School was built. The school was henceforth known as Central School and continued to house some primary classes and all high school classes. The building was remodeled and expanded around 1903. In October 1908, the building burned and was declared a total loss valued at around $35,000. Classes were held in the courthouse and churches until construction was completed on a new school. (Above, R. Taliaferro Jones, 1907; below, unknown publisher, real photo, 1908.)

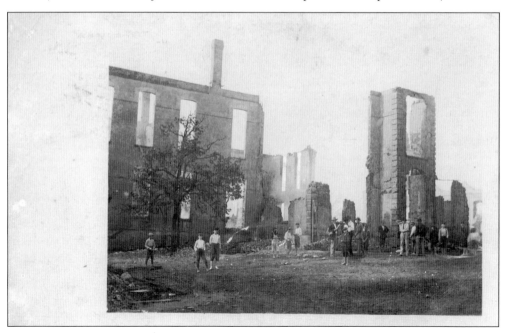

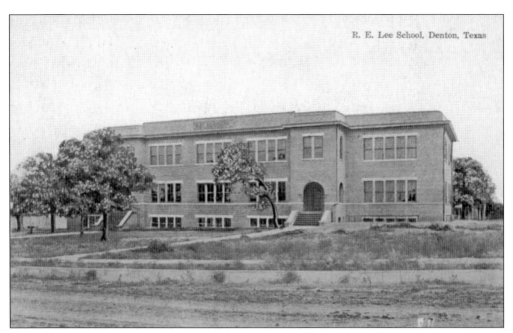

R. E. Lee School, Denton, Texas

R. E. LEE SCHOOL. Following the destruction of the Central School, Robert E. Lee School opened in the fall of 1909 on the same site. High school students attended the school with the primary students until the high school moved to its own campus in 1912. In 1923, a new building was constructed and featured a sidewalk sponsored by local business owners and citizens. Lee Elementary School moved to Mack Place in 1974 and the building was demolished, ending a century-long tradition of education at that site. (Bradford and Company, 1912.)

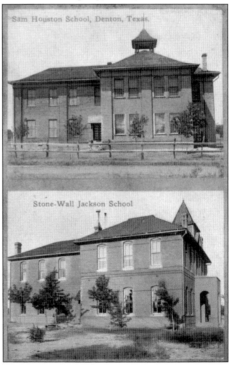

Sam Houston School, Denton, Texas.

Stone-Wall Jackson School

SAM HOUSTON SCHOOL/STONE-WALL (STONEWALL) JACKSON SCHOOL. The West Ward School was built in 1905 and renamed Sam Houston in 1909. It was located on Welch Street near the North Texas State Normal College. The school closed in 1974 and was purchased by the university, which built parking on its site. The current Sam Houston Elementary School opened on Teasley Lane in 1982. North Ward School, renamed Stonewall Jackson School in 1909, opened in 1899 on Gary Street. After it burned in 1916, a new building was constructed. The school was phased out in 1982–1983, and the old structure was torn down. (Unknown publisher, 1909–1916.)

59

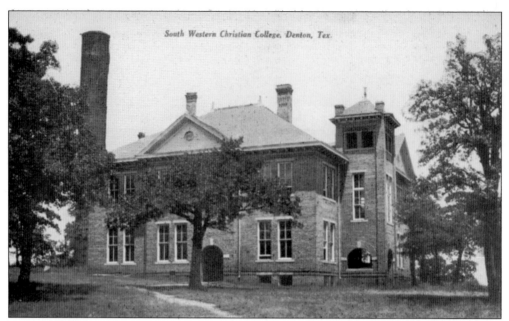

South Western Christian College, Denton, Tex.

SOUTH WESTERN (SOUTHWESTERN) CHRISTIAN COLLEGE/SOUTHLAND UNIVERSITY. John B. Denton College opened on September 10, 1901, in a two-story newly constructed building on John B. Denton Street. O. H. Thurman was president. Enrollment declined in 1904 after the opening of the Girls' Industrial College in 1903, the second state college in the city. The board sold the property to the Church of Christ, which operated the school as Southwestern Christian College from 1904 to 1908. Much of the curriculum focused on Bible study and ministerial training. In 1908, the school was rechartered as a university and became Southland University under the direction of Allen Booker Barret. The new institution was not successful and closed in 1909. Barret opened a school in Cleburne, which later moved to Abilene and became Abilene Christian College. The Denton campus passed to the Denton School District. (Above, R. Taliaferro Jones, *c.* 1907–1908; below, unknown publisher, 1909.)

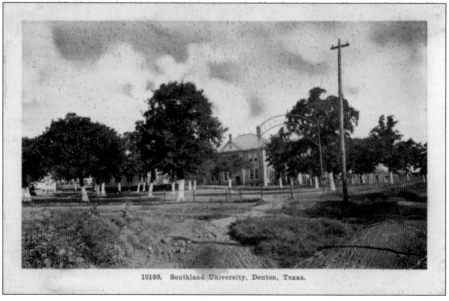

10180. Southland University, Denton, Texas.

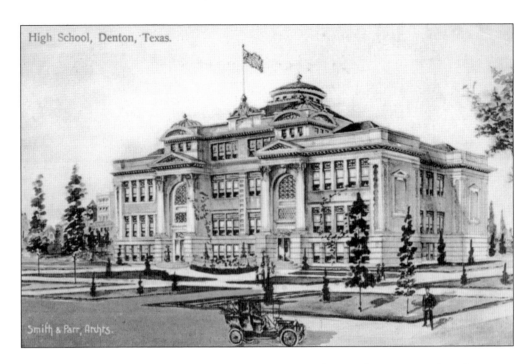

High School, Denton, Texas.

Smith & Parr, Archts.

DENTON HIGH SCHOOL CAMPUS. As the student population of Denton continued to grow, the Lee School, although relatively new, was becoming overcrowded. The building housed the only high school of approximately 244 students as well as elementary classes. The initial plan was to build a separate high school, pictured above. Instead, the Denton School District acquired the former Southland University campus and in 1912 transferred the high school to the old college building. (Above, A. M. Simon, made in Germany, *c.* 1911; below, unknown publisher, 1916.)

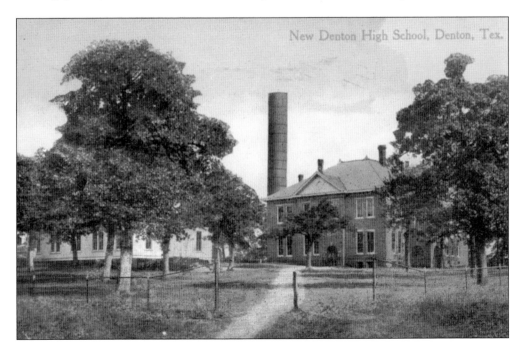

New Denton High School, Denton, Tex.

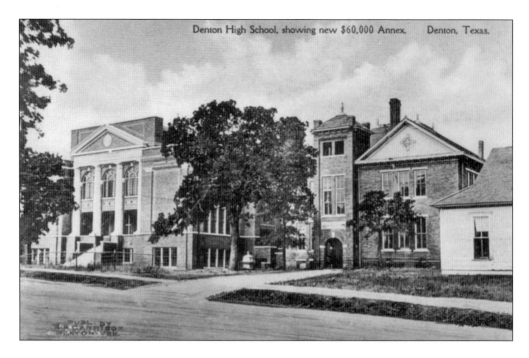

Denton High School, showing new $60,000 Annex. Denton, Texas.

DENTON HIGH SCHOOL SHOWING NEW $60,000 ANNEX. By 1916, the high school at the former John B. Denton/Southland campus was experiencing overcrowding. In February 1916, ground-breaking began on a new building to be constructed adjacent to the old structure. Sanguinet and Staats were the architects, and the building cost $60,000. The old building was then used as an annex housing a gymnasium, manual arts classroom, and music room. (Above, O. M. Curtis by Albertype, 1916–1924; below, J. A. Garrison by Albertype, c. 1916.)

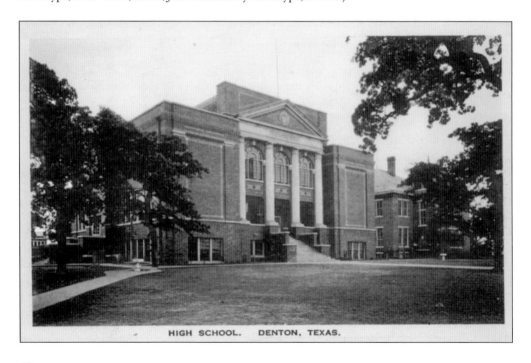

HIGH SCHOOL. DENTON, TEXAS.

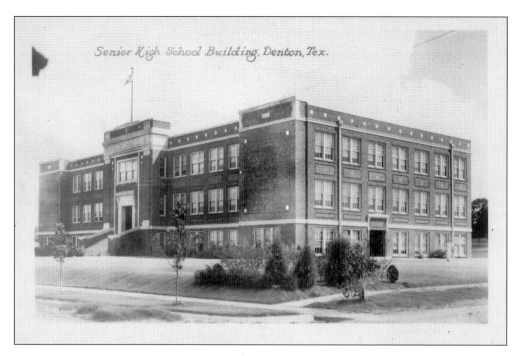

SENIOR AND JUNIOR HIGH SCHOOL BUILDINGS. In 1924, a new high school building opened at 709 Congress Street at the north end of the campus. The junior high school remained in the old building. The 68,310-square-foot, three-story structure was built by Wiley G. Clarkson at a cost of $140,000. In 1957, a new high school opened on Fulton Street and the Congress Street building became the junior high. Amos O. Calhoun was the principal of the high school from 1924 through 1957 and would be honored in 1982 when the building became Calhoun Junior High. (Above, Photo and Art Postal Card Company, real photo, 1930s; below, C. E. Carruth, *c.* 1936–1952.)

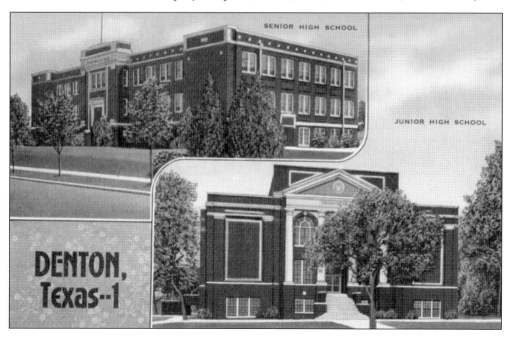

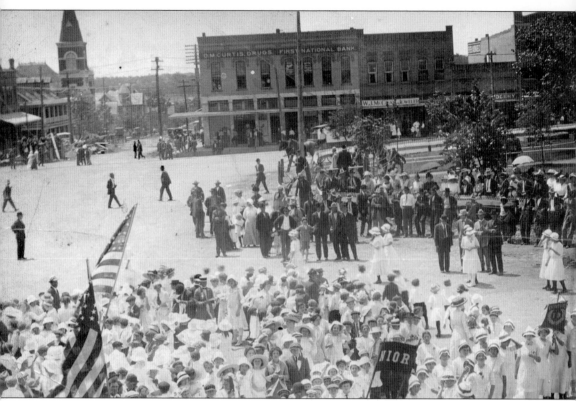

EDUCATION DAY RALLY ON THE SQUARE. Denton staged an educational rally day and parade on May 15, 1913, that ended on the downtown square. Students and teachers from the four public schools, North Texas Normal College, and the College of Industrial Arts participated in the event. (O. M. Curtis, real photo, *c.* 1913.)

Six

University of North Texas

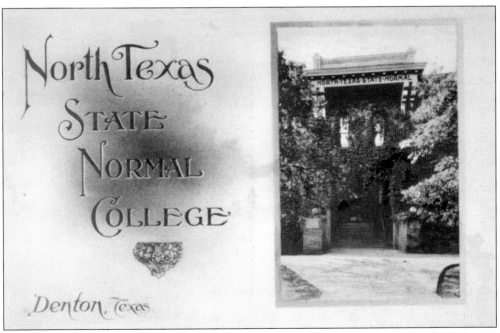

North Texas State Normal College. Joshua Crittenden Chilton opened the Texas Normal College and Teachers Training Institute in Denton on September 16, 1890. The following year, the city constructed the first building on land donated by W. A. Ponder. The Normal Building faced West Hickory Street at Avenue B. This postcard is the cover card for a rare postcard booklet that contained seven detachable cards plus the cover card. This booklet included several buildings and campus scenes. (MC; O. R. Dyche Normal Pharmacy by Albertype, *c.* 1920–1923.)

JUST A GREAT BIG FINE "HELLO" FROM DENTON. The state law allowing North Texas Normal College to issue teaching certificates passed in 1893, giving the Texas Normal College a new name by default. Gov. Joseph D. Sayers signed the bill creating the North Texas State Normal College on March 31, 1899, making the school a state institution. (Zercher Pioneers, genuine photograph mounted card, 1912.)

SPIRIT AND YELL CARD. This is a yell from the State Normal, "Boom-a-lacka. Boom-a-lacka. Bow-wow-wow. Ching-a-lacka. Ching-a-lacka. Chow-chow-chow. Boom-a-lacka. Ching-a-lacka. Who are we? We are students of T. N. C. [Texas Normal College]." The message written on the back gives some insight into the workload at the college, "These teachers give you so much to do that you don't have much time to be lonesome. We have a nice boarding place and have met some really sweet girls. 94 West Sycamore. Fern." (Unknown publisher, 1912.)

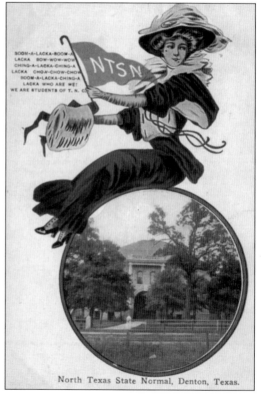

North Texas State Normal, Denton, Texas.

ORGANIZED in 1901, and maintained by the State for the professional training of teachers. Session of nine months begins annually in September and closes in May.

Faculty of seventeen teachers.

Enrollment of 575 students annually from more than 200 counties.

Commodious buildings, heated by steam and lighted by electricity.

Beautiful campus, ample athletic field and tennis courts.

Extensive library, laboratories and apparatus.

Superior boarding facilities in more than sixty homes.

The demand for teachers educated here demonstrates public confidence.

NORTH TEXAS STATE NORMAL COLLEGE
Located at Denton, Texas

TUITION FREE. TOTAL FEES FOR NINE MONTHS' SESSION, $15.

DENTON HAS

Two trunk lines of railroad. Twelve daily passenger trains. Modern systems of waterworks, electric lights and trolley cars. Abundance of purest artesian water. Many elegant churches and handsome residences. A cultured citizenship. Free mail delivery after May 15, 1908. Efficient system of public free schools. One denominational college. Two State educational institutions.
Write for catalogue and particulars.

W. H. BRUCE, Ph. D., President.

NORTH TEXAS STATE NORMAL COLLEGE RECRUITMENT CARD. Under the administration of Pres. William Herschel Bruce (1906–1923), recruitment by 1910–1911 had already more than doubled its annual enrollment from 732 to 1503. This advertising postcard was mailed to thousands of Texas high school students in 1908. It was also used by students for correspondence. (DCM; unknown publisher, 1908.)

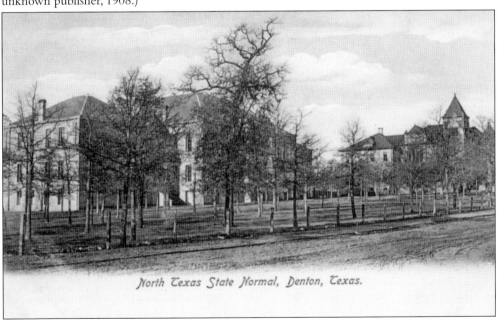

North Texas State Normal, Denton, Texas.

NORTH TEXAS STATE NORMAL COLLEGE EARLIEST BUILDINGS. This card shows the two buildings that were on campus during its earliest years. On the right is the Normal Building, the first building to be constructed on campus in 1891; on the left is the Administration Building (Main Building), constructed in 1904. Both faced West Hickory Street between Avenue A and Avenue B. The Normal Building was struck by lightning and burned in 1907. (Unknown publisher, printed in Germany, *c.* 1904–1907.)

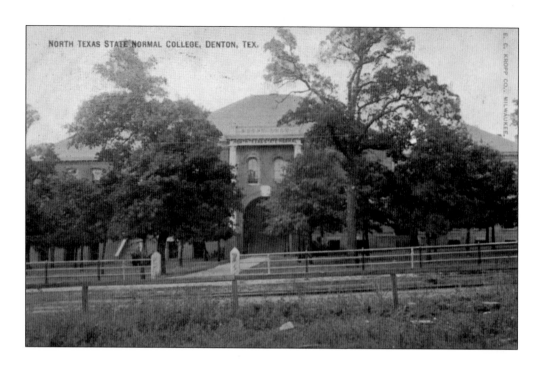

NORTH TEXAS STATE NORMAL COLLEGE ADMINISTRATION BUILDING. The Administration Building, constructed in 1904, was the second permanent structure on the campus. It housed the library, administration offices, classrooms, and an auditorium. The auditorium could seat 1,200 people. The Administration Building was razed in 1923. (Above, E. C. Kropp, 1910; below, O. R. Dyche Normal Pharmacy by Albertype, c. 1920.)

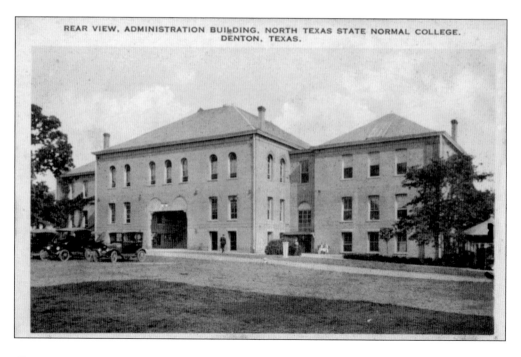

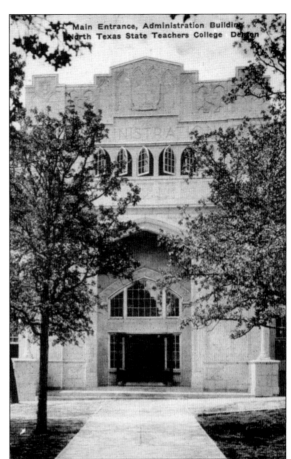

MAIN ENTRANCE, ADMINISTRATION BUILDING (1923). The 38th Texas Legislature of 1923–1924 granted $300,000 to build the second Administration Building for the Teachers College facing West Hickory Street. The Administration Building is now mostly used by the English, the linguistics, and technical communications departments and is called the Auditorium Building. (At right, O. R. Dyche Busy Corner Drug Store by Albertype, 1928; below, Curt Teich, 1931.)

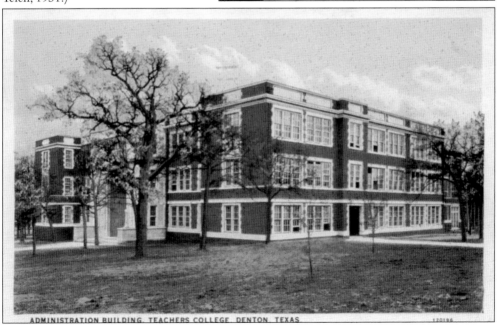

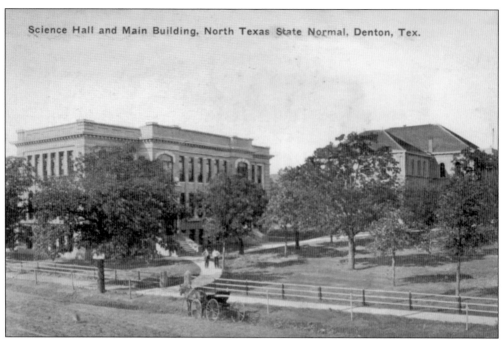

Science Hall and Main Building, North Texas State Normal, Denton, Tex.

SCIENCE HALL AND MAIN BUILDING. The Science Hall was completed and furnished in 1910 at a cost of $40,000, but it served many purposes other than science instruction. It contained six recitation rooms, chemical and physical laboratories, manual training shop, mechanical drawing room, domestic science rooms, model dining room, engine room, office for teachers, and a large room for lectures in chemistry and physics. The Board of Regents purchased a gas manufacturing plant in 1910 to provide gas for the domestic science cooking room and chemical laboratory. The message written on the back of the bottom postcard reads, "This is the building I have my chemistry lesson in." (Above, E. C. Kropp, 1914; below, J. D. Hodges by Albertype, 1916.)

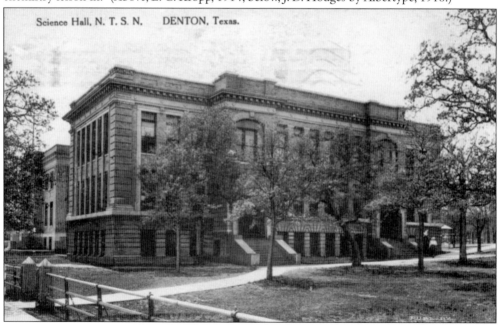

Science Hall, N. T. S. N. DENTON, Texas.

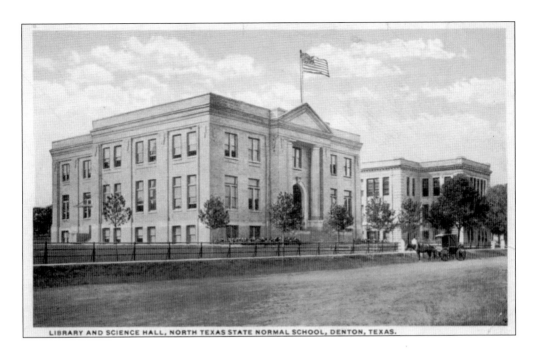

LIBRARY AND SCIENCE HALL. The first library building was completed at a cost of $55,000 and occupied in 1913. The library was located on the entry level, a gymnasium on the lower level, and classrooms and meeting rooms on the third level. After the new library opened in 1936, this building became known as the Historical Building and housed a museum. In the 1990s, it was renamed Curry Hall to honor the college's first business dean, O. J. Curry. (Above, Curt Teich, *c.* 1913–1916; below, Duke and Ayres Nickel Stores by C. T. Photochrome, *c.* 1914.)

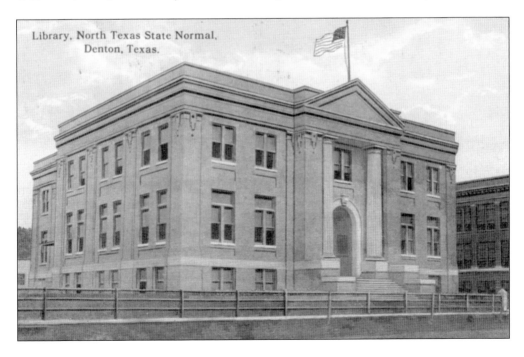

Library, North Texas State Normal,
Denton, Texas.

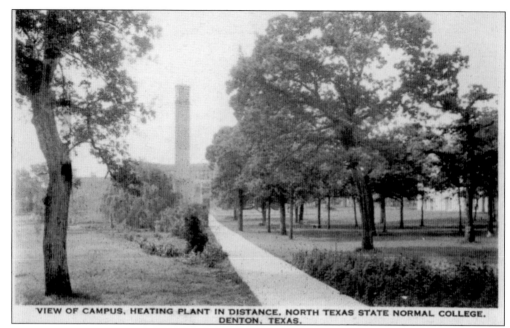

VIEW OF CAMPUS, HEATING PLANT IN DISTANCE, NORTH TEXAS STATE NORMAL COLLEGE. DENTON, TEXAS.

VIEW OF CAMPUS. Early presidents of the school had each requested appropriations for funding of heat and power from the legislature. John J. Crumley took over the administration of the Normal College in 1893. President Crumley recalled that he and two other men "went into the dense stand of young post oak timber south of the College building and cut wood to burn in [the] stoves." The heat and power plant was completed in 1915 at a cost of $35,000. Heat was important enough to feature on this postcard taken not long after the plant was built. Students enjoy a mild Texas day studying and relaxing on the lawn facing West Hickory in front of the Science and Main Buildings in the postcard below. (Above, O. R. Dyche Normal Pharmacy by Albertype, *c.* 1915-1923; below, E. C. Kropp, 1916.)

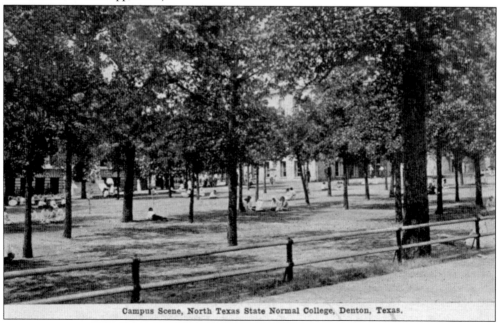

Campus Scene, North Texas State Normal College, Denton, Texas.

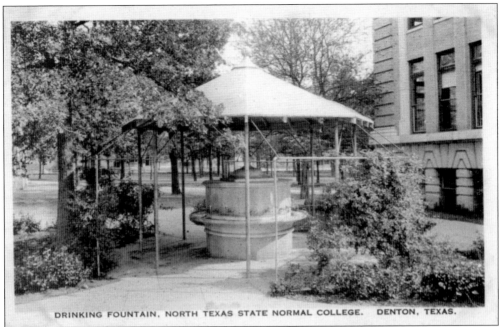

DRINKING FOUNTAIN, NORTH TEXAS STATE NORMAL COLLEGE. DENTON, TEXAS.

DRINKING AND WATER FOUNTAINS. Sufficient water was an issue from the college's earliest days. The state act creating the school specified that Denton would provide abundant pure artesian water free of charge to the college. In 1912, President Bruce recalled getting a telephone call from the city water works superintendent that he was going to cut off the water to the campus because the college was using too much. President Bruce resolved the issue by threatening to take the college to Oak Cliff. The water superintendent expressed concern that the college could "even put in a swimming pool." To which President Bruce replied, "Yes, and as soon as I get a suitable place for it, I'm going to put one in." Nothing was said again about decreasing campus water supplies. The water fountain, located near the Science Hall, was a popular student-gathering place in the 1920s. When the Science Hall was demolished in 1967, the gazebo from the water fountain was saved in the same location to preserve tradition. Drinking fountains appeared around the campus after 1920 much to the delight of students and faculty walking to classes on hot Texas days. (Both images MC; O. R. Dyche Normal Pharmacy by Albertype, *c.* 1912–1923.)

CAMPUS SCENE, NORTH TEXAS STATE NORMAL COLLEGE. DENTON, TEXAS.

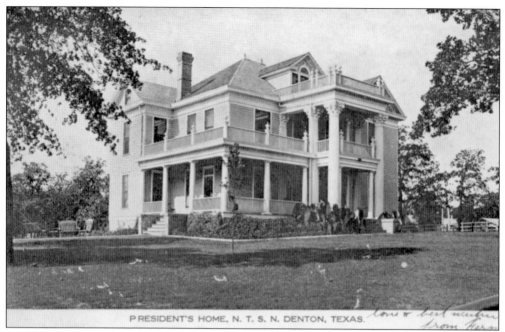

PRESIDENT'S HOME, N. T. S. N. DENTON, TEXAS.

PRESIDENT'S HOME. The President's Home was constructed in 1909 at a cost of $5,000. This two-story frame house was built on the site of the old Normal Building and was first used by President Bruce and his family. A 1956 assessment of college assets showed that the home was worth $67,944. The house was razed in 1958. The message on the back of this card reflects Fern's experience as a new teacher, "I am like the old woman who lived in the shoe. I have 86 children and had 83 present on Tuesday. We have enrolled 350 in the school. Fern." (A. Zeese Engraving, 1914.)

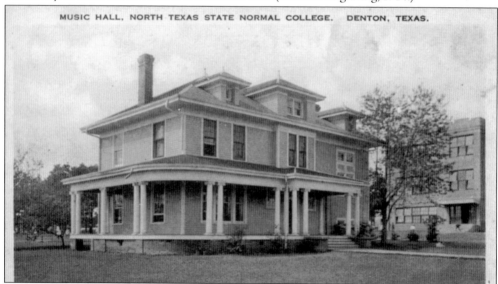

MUSIC HALL, NORTH TEXAS STATE NORMAL COLLEGE. DENTON, TEXAS.

MUSIC HALL. The earliest building for music training on campus, called Kendall Hall, was the two-story former home of Pres. Joel Sutton Kendall. The house faced Chestnut Street. In 1931, another house next door to Kendall Hall was also used for music instruction. In 1940, the college built another Music Hall, and Kendall Hall was taken over by the speech department. (O. R. Dyche Normal Pharmacy by Albertype, *c.* 1920–1923.)

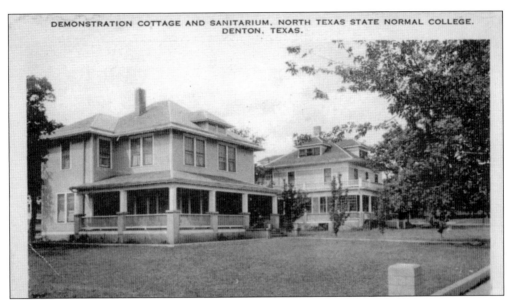

DEMONSTRATION COTTAGE AND SANITARIUM. The Demonstration Cottage, a two-story frame building located on Sycamore Street, was dedicated to the education of home economics students in the practical use of domestic science. In 1919, a practical nurse was employed as matron of the college sanitarium. In September 1919, the J. W. Smith residence at Avenue B and Sycamore Street was converted into a hospital building. A fee of $1 per session was assessed to students, faculty, and their immediate families for health services at the school hospital. (O. R. Dyche Normal Pharmacy by Albertype, c. 1920–1923.)

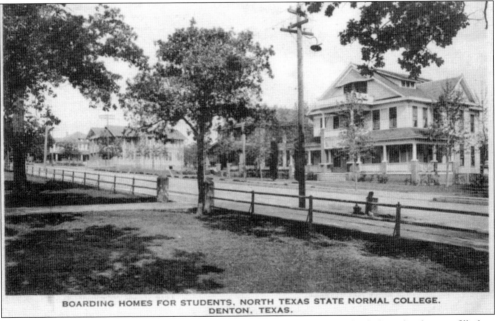

BOARDING HOMES FOR STUDENTS. Before college dormitories were built, boardinghouses filled an important need for student housing. By 1910, more than 80 private boardinghouses provided room and board for students. Boardinghouse fees ranged from $22.50 to $26.50 per month. This postcard includes Hodges' Boardinghouse. (O. R. Dyche Normal Pharmacy by Albertype, c. 1920–1923.)

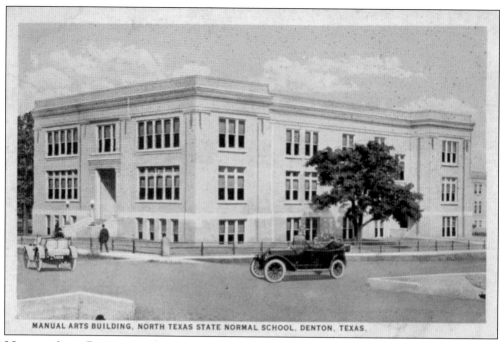

MANUAL ARTS BUILDING, NORTH TEXAS STATE NORMAL SCHOOL, DENTON, TEXAS.

MANUAL ARTS BUILDING. The Texas Legislature passed an act in 1910 mandating that all normal colleges offer courses in manual training and home economics. In 1912, these two courses fell under the title of Industrial Arts. It was not until 1915 that the Manual Arts Building, later known as the Arts Building, was completed at a cost of $65,000 for the building and equipment. The building was not used until 1916. (Curt Teich, *c.* 1920.)

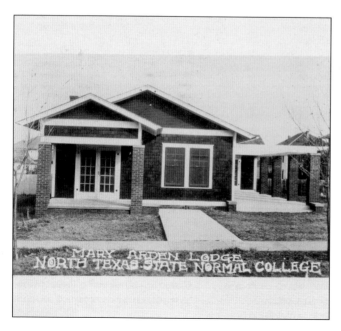

MARY ARDEN LODGE. The Mary Arden Club, named after William Shakespeare's mother, was organized as a literary society for women in 1902 to study Shakespeare's works. The club built the Mary Arden Lodge on Avenue A that served for many years as its meeting place and as a site of teas and other social activities. The club remained active until the 1970s. Another campus club, the Current Literature Club, was founded in 1901 by Anne Moore and Annie Webb Blanton to study *McClure's, Harpers, the Century*, and *Cosmopolitan* magazines and current events. (Unknown publisher, *c.* 1923.)

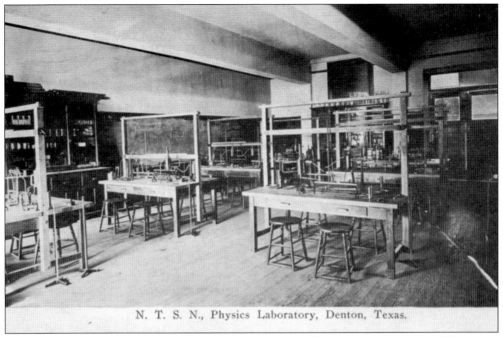

N. T. S. N., Physics Laboratory, Denton, Texas.

NTSN PHYSICS LABORATORY. The Physics Laboratory was located in the Science Building along with a large hall for the study of physics and chemistry. (A. Zeese Engraving, real photo, 1913.)

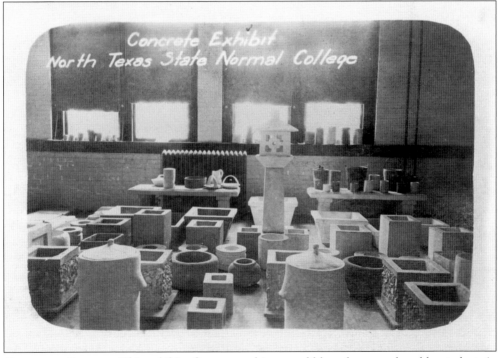

Concrete Exhibit
North Texas State Normal College

CONCRETE EXHIBIT. This exhibit of concrete objects could have been produced by students in the Manual Arts program to be used on campus as planters, fountains, vases, smoking stands, and light posts. (Unknown publisher, real photo, c. 1915–1923.)

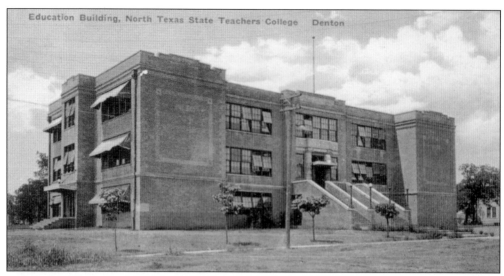

EDUCATION BUILDING. An appropriation of $80,000 in 1917 was made to fund the construction and equipment costs of the Education Building. However, due to World War I shortages, the building was not completed and occupied until 1919. Located between Sycamore and Chestnut Streets, the building held offices for the education faculty and the training school domestic science lab. A unique feature on the third floor was a large observation room designed to give college classes the opportunity to observe demonstration lessons by a critic teacher and her class. (Albertype, *c.* 1923.)

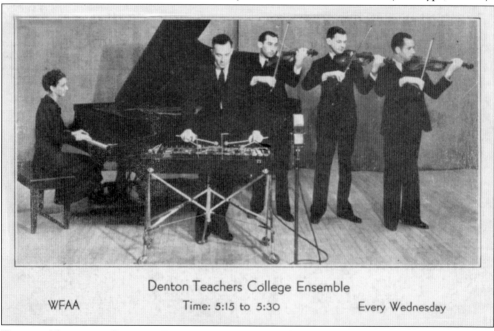

Denton Teachers College Ensemble

WFAA Time: 5:15 to 5:30 Every Wednesday

DENTON TEACHERS COLLEGE ENSEMBLE. Pres. W. Joseph McConnell announced in 1938 that an enlarged and combined Music Department was being created with Dr. Wilfred C. Bain serving as department head. Dr. Bain organized the college's first a capella choir, which was heard on WFAA radio station in Dallas. Other campus music organizations in 1938 included a radio ensemble for regular broadcast over WFAA. This advertisement postcard announces the time of the Denton Teachers College Ensemble as 5:15–5:30 p.m. every Wednesday. (Unknown publisher, *c.* 1938.)

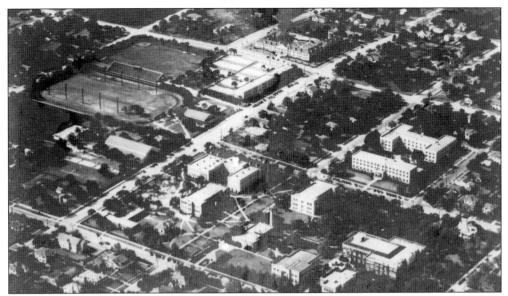

AIRPLANE VIEW OF NORTH TEXAS STATE TEACHERS COLLEGE. The original campus was bordered by Hickory Street on the north, Sycamore Street on the south, Avenue A on the east, and Avenue B on the west. This aerial view of the campus is from the 1940s and shows the newly completed Chilton and Terrill Dormitories, Music Hall, and the library. The recreation park is shown in the upper left of the postcard. (Defender, real photo, *c.* 1941–1948.)

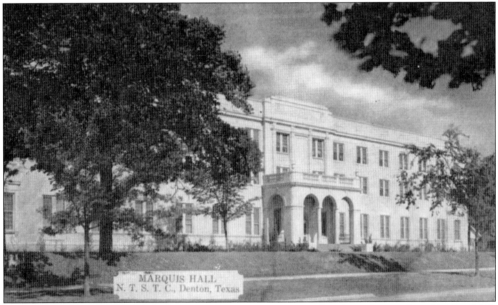

MARQUIS HALL. Named for Robert Lincoln Marquis, the college's sixth president (1923–1934), Marquis Hall was the first college-owned dormitory. Built in 1936 for 114 women residents at a cost of $212,000, the dormitory was located between Sycamore and Mulberry Streets at Avenue B. Room and board was provided for $26 to $27.50 per month. Residents were allowed to entertain men from 5:00 to 7:00 p.m. on study nights and until 11:00 p.m. on Saturday and Sunday. Many university and community functions were held in Marquis Hall's Crystal Room. Marquis Hall was no longer used as a dormitory in the late 1960s. (Dexter Press, *c.* 1940.)

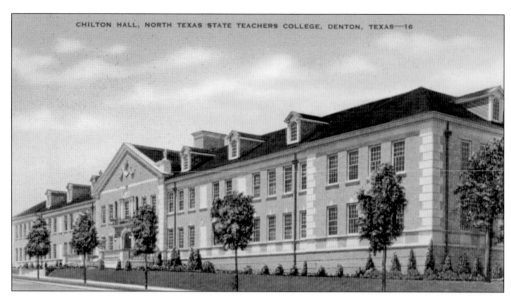

CHILTON HALL. Chilton Hall was named in honor of Pres. Joshua C. Chilton (1890–1893), founder of the Normal school. Built in 1939, on Avenue C between Chestnut and Prairie Streets, at a cost of $257,727, Chilton Hall was touted as one of the best-equipped men's dormitories in the South. Room and board was $22.50 per month. The building contained nine separate suites that would accommodate 216 students; each unit had a private entrance, bath for each two rooms, and access to ice water. A modern kitchen and dining hall provided meals for more than 300 students. The hall included a reception room, office, checkroom, and laundry. (C. E. Carruth by E. C. Kropp, *c.* 1943.)

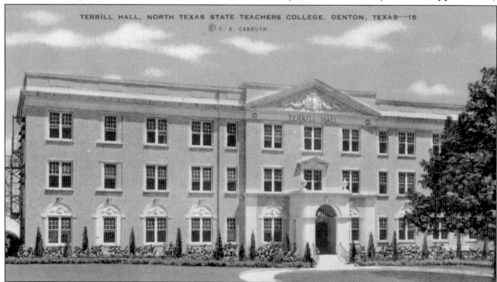

TERRILL HALL. Named for Menter B. Terrill, the third president of the Normal College (1894–1901), Terrill Hall was the second women's dormitory. Room and board was between $26 and $27.50 per month. The three-story building was constructed in 1939 for $313,000 to accommodate 226 women. The building was fireproof, steam heated, acoustically treated, and featured two closets for every room, a lavatory with hot and cold water, attractive built-in furniture, and a buzzer system. The Great Hall on the first floor was an entertainment room with a dancing capacity for 250 couples. (C. E. Carruth by E. C. Kropp, *c.* 1943.)

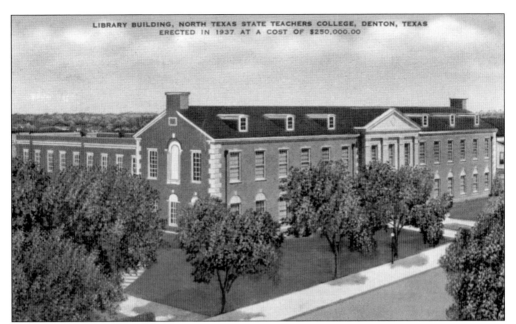

LIBRARY BUILDING. Constructed in 1936 at a cost of $250,000, the new Library Building was partially funded by the Public Works Administration. The college is one of the earliest library schools to be accredited in the United States. When Willis Library was built in 1978, structure became the Information Sciences Building. (C. E. Carruth by E. C. Kropp, *c.* 1943.)

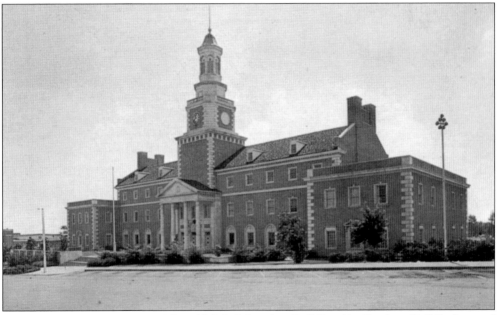

ADMINISTRATION BUILDING. The old Administration Building (Auditorium Building) served until 1956 when a new Administration Building was constructed in the center of campus. The building's tower and carillon were dedicated as the McConnell Memorial Tower in honor of W. Joseph McConnell, who served as president of North Texas State Teachers College for 17 years. The tower overlooked the 22 major buildings that were constructed during McConnell's administration. (Burchard's Studio by Dexter Press, *c.* 1961.)

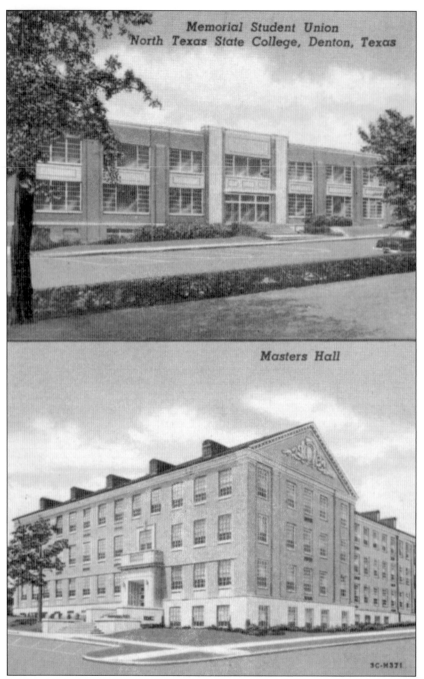

MEMORIAL STUDENT UNION AND MASTERS HALL. The Student Union Building, dedicated in 1949, was one of the most popular meeting places on the college campus. The building housed the college bookstore, post office, a snack bar and cafeteria, and a large lounge. In addition to these accommodations were numerous offices, club rooms, and an auditorium. Masters Hall, completed in 1952 at an estimated cost of over $1 million, housed the biology and chemistry department, classrooms, offices, an auditorium, and research and teaching laboratories equipped for a modern science program. (Fultz News Agency by Curt Teich, 1950s.)

BRUCE HALL AND WEST OAK STREET HALL.
Bruce Hall, named for Pres. William H. Bruce, was
completed in 1948 at a cost of $1,178,000. The hall
accommodated 500 co-eds. Oak Street Hall was
built in 1940–1941 with financial assistance from
the Public Works Administration. The building cost
$65,000 and housed 100 female students. An annex
to the hall costing $335,000 opened in 1947.
When integration took place at the college in
1956, two African American female students lived
in Oak Street Hall. (Fultz News Agency by Curt
Teich, 1950s.)

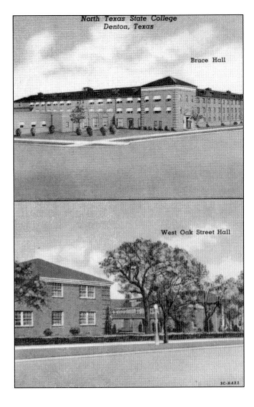

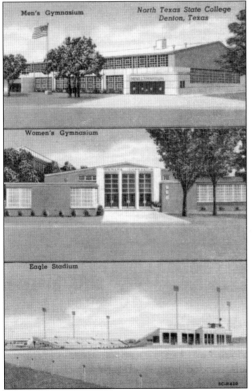

**MEN'S GYMNASIUM, WOMEN'S
GYMNASIUM, AND EAGLE STADIUM.** This
multi-view postcard features the men's
gymnasium built in 1950, the women's
gymnasium built in 1951, and Eagle
Stadium (Fouts Field) built in 1952. The
men's gymnasium was known as "the Pit."
Traditional sports offerings included tennis,
soccer, basketball, golf, track and field, baseball,
and football. (Fultz News Agency by Curt
Teich, 1950s.)

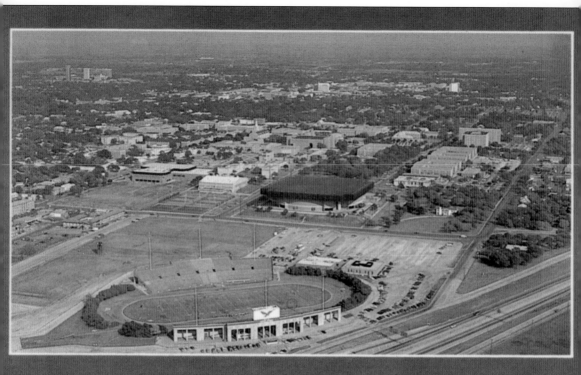

NORTH TEXAS STATE UNIVERSITY

OVERVIEW OF FOUTS FIELD AND THE CAMPUS. This aerial view of the college campus was taken in the 1980s before the name changed to the University of North Texas in 1988. Predominantly featured is Fouts Field, named for Theron Fouts—football coach, athletic director, and dean of men. In the center of the postcard is the Coliseum that was built in 1973, the location where basketball is played and graduation ceremonies take place. (Photograph by Herb Alden for Texas Postcard Company, *c.* 1963–1988.)

Seven

TEXAS WOMAN'S
UNIVERSITY

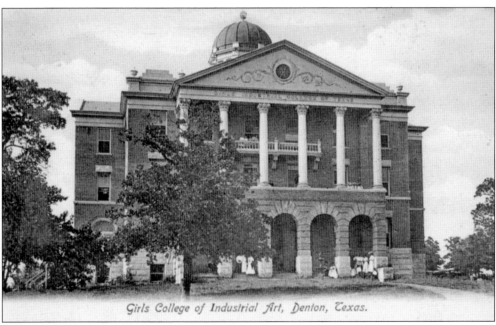

Girls College of Industrial Art, Denton, Texas.

GIRLS COLLEGE OF INDUSTRIAL ARTS. The Texas Legislature established the Girls' Industrial College of Texas in 1901. In 1903, the first bulletin announced that enrollment was open to "all white girls of good moral character who have attained to the age of 16." The first term of the college began on September 23, 1903. Tuition was free, and students paid a one-time matriculation fee of $5 and an incidental fee of $5 each term. Textbook rental, a material fee, and a hospital fee to cover medical expenses cost approximately $10 per year. One hundred and seventy-three students attended the first term. (Unknown publisher, printed in Germany, *c.* 1905.)

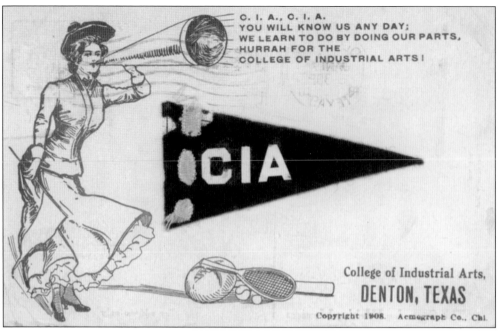

C. I. A., C. I. A.
YOU WILL KNOW US ANY DAY;
WE LEARN TO DO BY DOING OUR PARTS,
HURRAH FOR THE
COLLEGE OF INDUSTRIAL ARTS!

College of Industrial Arts,
DENTON, TEXAS

Copyright 1908. Acmegraph Co., Chi.

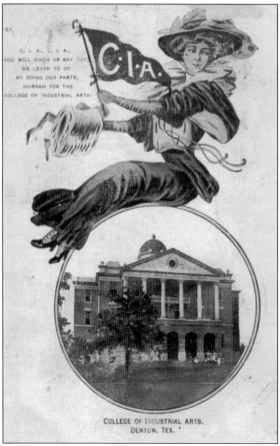

COLLEGE OF INDUSTRIAL ARTS,
DENTON, TEX.

CHEERLEADER CARD WITH MOTTO.
The cornerstone for the college's first
building was laid in 1903. Cree T.
Work (1903–1910) was appointed the
first president of the Girls' Industrial
College. In 1905, the name changed to
the College of Industrial Arts (CIA).
The adopted motto, suggested by
Helen Stoddard, using educator John
Amos Comenius' phrase "We learn
to do by doing," was engraved on a
pillar of the college's first building. The
motto reflected the college's mission
to educate women and is one of the
lines of the poem on this postcard.
The college changed its name in 1934
to Texas State College for Women
(TSCW) and again in 1957 to Texas
Woman's University (TWU). (Above,
Acmegraph Co., c. 1910; at left,
unknown publisher, c. 1911.)

86

SINCE I STRUCK DENTON. The irony of this card is that the social, academic, and athletic activities provided for students far exceeded anything they would have experienced in their home lives. President Work stated that the "Girls Industrial College of Texas [would] aim to give culture of the highest order, scholarship of the most efficient kind, and domestic and industrial training of the most modern and practical type . . . training women who will be competent, intelligent and refined." Many activities contributed to the social, cultural, and moral development of students. Chorus and glee clubs, an orchestra, and literary societies were formed, and tennis, basketball, and golf had their own instructors. (Zercher Pioneers, real photo mount, *c.* 1905.)

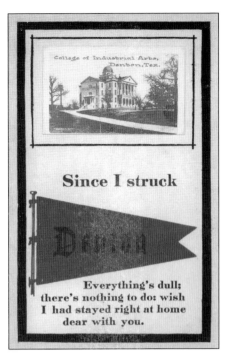

MAKING HAY. Professor Charles Noble Adkisson took this photograph of staff harvesting hay on the grounds of the college in 1908. Professor Adkisson was one of the first faculty members and taught chemistry and physics. The rural arts department taught skills in dairying, poultry raising, canning and preserving, and other farming issues. A 7-acre truck patch, home garden, orchard, 300 fowl for breeding experiments, a 50-animal hog farm, and a greenhouse offered practical hands-on training to students, many of whom came from rural areas. (Prof. C. N. Adkisson, unknown publisher, printed in Germany, *c.* 1908–1910.)

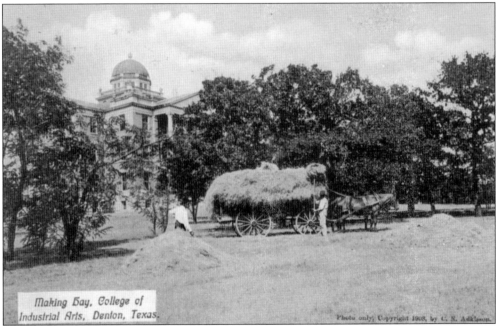

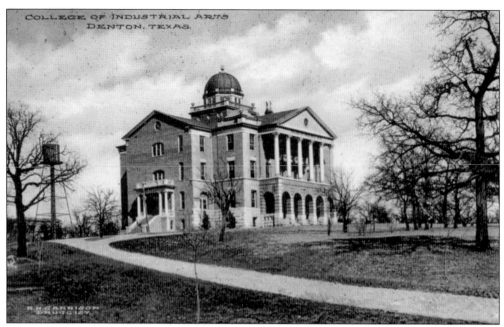

COLLEGE OF INDUSTRIAL ARTS ADMINISTRATION BUILDING. In 1903, the original building (later designated the Academic Arts Building, the Administration Building, and Old Main) was opened to 186 students with a faculty of 14. Four major courses of study were offered: English-science, domestic arts, fine and industrial arts, and commercial arts. (Above, R. H. Garrison by Albertype, *c.* 1905–1916; below, unknown publisher, *c.* 1905–1916.)

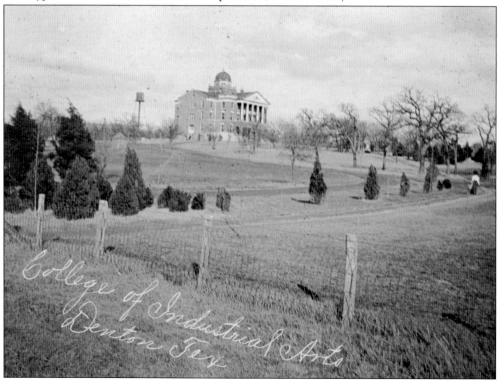

TSCW/CIA Administration Building. "On broad and rolling plains 'Neath Texas skies, There, crowned with majesty, Thy buildings rise" is written on the front of this card. It is the original version from the CIA Alma Mater Song composed by Mamie Walker, who was in the class of 1917. A revised version of the song was adopted in 1977 to remove the reference to CIA. The text on the back reads, "The college is the only state-supported college for women in Texas. Its campus contains 100 acres." (Unknown publisher, *c.* 1937.)

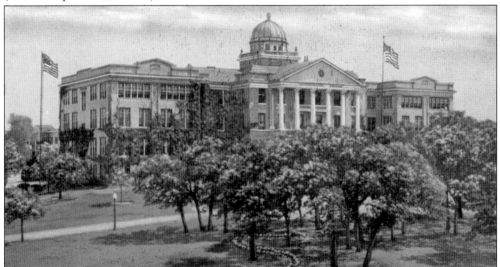

Administration Building Texas State College for Women. The narrative on the back of this postcard reads, "This building was erected in 1903 at a cost of $60,000.00, in 1916 made fireproof; and two wings were added at a cost of $100,000.00. It is a four story structure and contains about 85 class rooms and business offices, including the administrative office of the college." After the construction of the Household Arts Building, the original administrative "main" building became known as the Academic Arts Building. (C. E. Carruth, 1940s.)

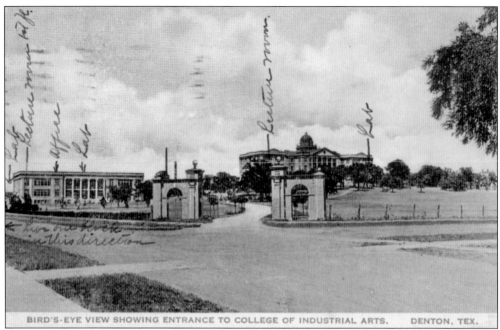

BIRD'S-EYE VIEW SHOWING ENTRANCE TO COLLEGE OF INDUSTRIAL ARTS. DENTON, TEX.

BIRD'S-EYE VIEW SHOWING ENTRANCE TO COLLEGE OF INDUSTRIAL ARTS. The Household Arts and Academic Arts Buildings are labeled in the handwriting of the sender "labs, office, lecture rooms. Live one block in this direction." The message on the back reads, "It's slow work with six day sessions. My sole business is to see that ten practice teachers do as they should. I like it here very much. New director-organization of whole school seems good and it works too. About 1400 girls here." (Whitson and McDade by Albertype, 1920.)

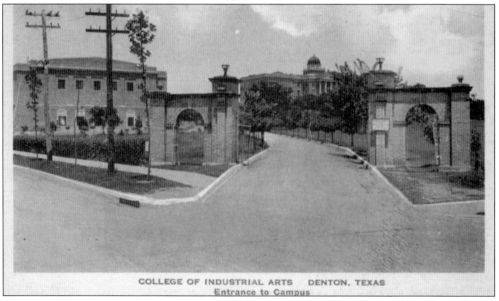

COLLEGE OF INDUSTRIAL ARTS DENTON, TEXAS
Entrance to Campus

ENTRANCE TO CAMPUS. The entrance to the campus underwent considerable changes in the two years between this and the above card. The Music Building was constructed in front of the Household Arts Building in 1922. Street and driveway improvements with telephone poles, curbs, and a drainage system were added. (Whitson and McDade by Albertype, 1923–1934.)

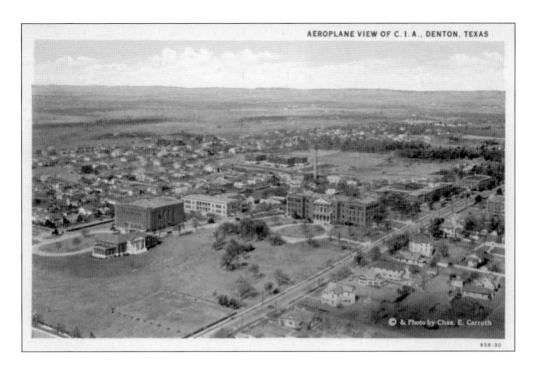

AEROPLANE VIEW OF C. I. A., DENTON, TEXAS

AEROPLANE VIEW OF THE COLLEGE. This aerial view of the College of Industrial Arts' 75-acre campus shows the new Library Building, the Music Hall, the Household Arts Building, and the Main Building in the center of postcard. The postcard below of the Texas State College for Women features the growth of the campus after the construction boom of the 1930s. (Above, photograph by C. E. Carruth by Curt Teich, 1928–1934; below, photograph by F. L. McDonald for C. E. Carruth, *c.* 1940.)

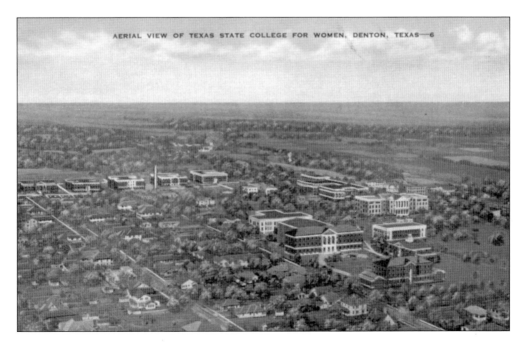

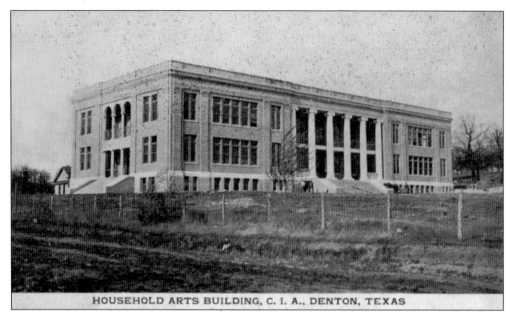

HOUSEHOLD ARTS BUILDING, C. I. A., DENTON, TEXAS

HOUSEHOLD ARTS BUILDING. Pres. William Bennett Bizzell (1910–1914) secured $75,000 for the second institutional building on campus, the Household Arts Building, constructed in 1911. The new two-story building had a large auditorium, classrooms for industrial arts, decorative arts, and domestic arts and science courses. The college instituted the first kindergarten at a state college in 1917 with room for 30 children and a laboratory for students engaged in practice teaching and observing children for courses in household arts. The first Demonstration School was in the Household Arts Building in the late 1930s. (A. Zeese Engraving, 1914.)

HOUSEHOLD ARTS AND SCIENCES BUILDING. When the Department of Home Economics moved from the old Household Arts Building to a new four-story building on Bell Avenue in 1951, under the leadership of Pres. John A. Guinn, the department became the College of Household Arts and Sciences with Pauline Berry Mack as its dean and director of research. Under Dr. Mack's leadership, the new college performed research projects in nutrition, textiles, and household science conducted by a staff of trained research engineers. (Burchard's Studio, c. 1960.)

92

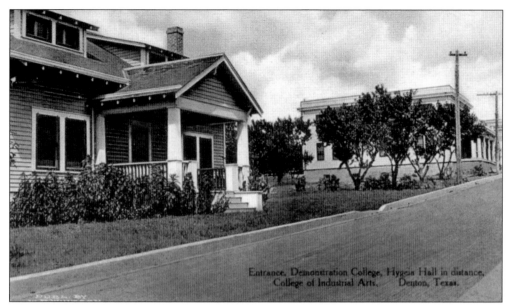

Entrance, Demonstration College, Hygeia Hall in distance,
College of Industrial Arts. Denton, Texas.

ENTRANCE DEMONSTRATION COTTAGE WITH HYGEIA HALL. The Demonstration Cottages provided senior students with the opportunity to assume the responsibility of managing a home. Prior to building a hospital, President Work gave up his private office for the use of the college physician. The first Hygeia Hall had the appearance of a colonial residence rather than an institutional hospital. After a new hospital was built, the old Hygeia was converted into a rooming house. A series of female physicians took care of the students' ailments. (W. F. Whitson by the Albertype, *c.* 1922.)

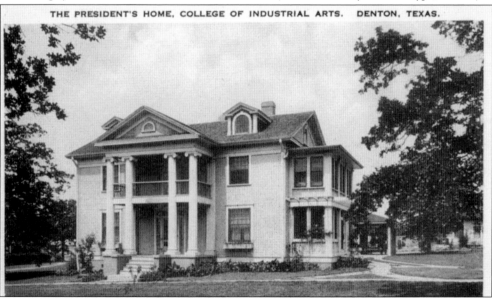

THE PRESIDENT'S HOME, COLLEGE OF INDUSTRIAL ARTS. DENTON, TEXAS.

PRESIDENT'S HOME. The President's Home, first occupied by William B. Bizzell in 1912, served as the residence of the college's leaders for almost 40 years. The college presidents used the two-story Georgian home for entertaining guests. It was replaced as the presidential residence in 1954 with a new home designed by Arch Swank, located at Bell Avenue and Highway 380. The new home sits in a grove of 25 post oak trees on top of a hill overlooking the college golf course. (Whitson and McDade by Albertype, *c.* 1920.)

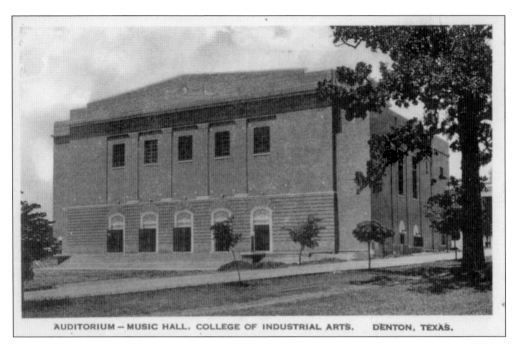

AUDITORIUM – MUSIC HALL, COLLEGE OF INDUSTRIAL ARTS. DENTON, TEXAS.

AUDITORIUM-MUSIC HALL. In 1904, vocal music was a requirement and a 60-voice chorus was organized. In 1908, instrumental music was offered as an option and a student orchestra was formed. The College of Industrial Arts was the first institution in Texas to develop a music department. The Auditorium-Music Hall was built in 1922 at a cost of $150,000. The auditorium had a large stage and a seating capacity of 2,500. The Music and Speech Building was connected to the south end of the Auditorium-Music Hall in 1936, forming a new entrance. (Above, Whitson and McDade by Albertype, *c.* 1922; below, C. E. Carruth, 1942.)

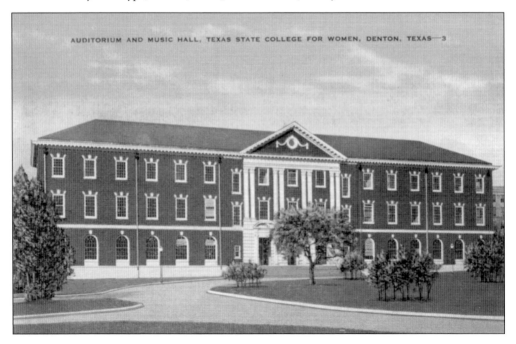

AUDITORIUM AND MUSIC HALL, TEXAS STATE COLLEGE FOR WOMEN, DENTON, TEXAS—3

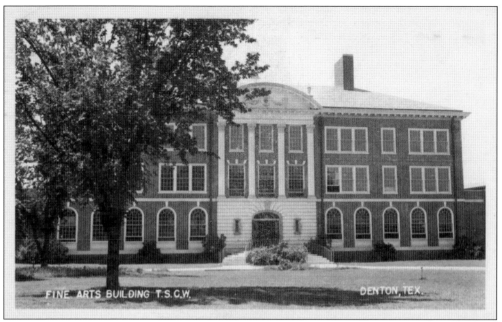

FINE ARTS BUILDING AND ART CLASS. The Fine Arts Building was constructed to the south of Old Main in 1936 and housed all courses in the fine arts. In addition to drawing, painting, designing, and engraving in an industrial application, pottery classes were an integral part of the college's curriculum. President Work recruited a young woman named Amelia B. Sprague to be the instructor in Fine and Industrial Arts. Sprague had already gained renown as one of the finest potters at Rookwood Pottery in Cincinnati, Ohio. Students did not produce pottery for commercial purposes. President Work took particular interest in pottery making after discovering a clay pit on campus that was suitable for pottery and china making. The above postcard has the message, "I took my pottery exam this morning and answered all the questions. Bernice." Below is a postcard of a drawing and painting class. (Both images, unknown publisher, real photos, 1940.)

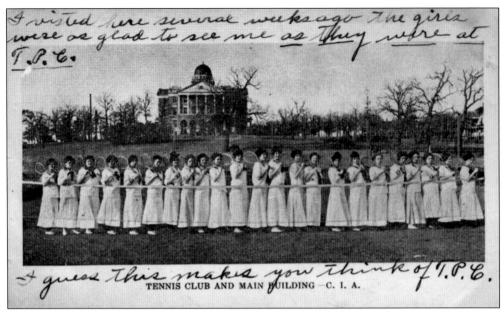

I visited here several weeks ago. The girls were as glad to see me as they were at T. P. C.

I guess this makes you think of T. P. C.

TENNIS CLUB AND MAIN BUILDING — C. I. A.

TENNIS CLUB AND MAIN BUILDING. Members of the tennis class appear in uniform in front of the Main Building. Tennis became the first competitive sport for the college in 1915 at a tournament with Trinity University. "I visited here several weeks ago. The girls were as glad to see me as they were at T. P. C. I guess this makes you think of T. P. C." is handwritten on the front. (TPC is Texas Presbyterian College that merged with Austin College.) (R. and C. Printery, Denton, 1913.)

SAILBOATS ON LAKE DALLAS. Students enjoyed all-college picnics at Lake Dallas Camp with boat trips in "Old Putt-Putt" and the sailboats that Marvin Loveless and Henry Blagg had built and shared with the college community. The college had exclusive control of a 20-acre tract on the shores of Lake Dallas, located only 20 minutes from the campus. Here students enjoyed boating, camping, and weekend recreation. (Unknown publisher, *c.* 1934–1936.)

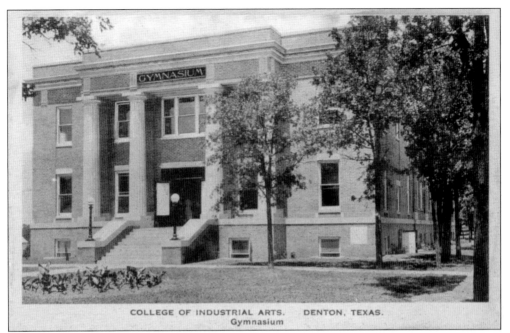

COLLEGE OF INDUSTRIAL ARTS. DENTON, TEXAS.
Gymnasium

GYMNASIUM. The Texas Legislature appropriated $170,000 for a new gymnasium that was completed in 1921 to replace the inadequate first gymnasium built in 1914. The new gymnasium contained a large tile-lined pool filled with clear artesian water of even temperature that was soon providing swimming lessons to 1,000 students a year. Water ballets were performed by the college's swim team in Texas's first indoor pool in the basement of the gymnasium. The water was kept clean and pure by frequent change and by use of a violet ray apparatus. (Curtis Company by Albertype, c. 1921–1934.)

SPORTS OFFERED. The Women's Athletic Association was started in 1911. Instruction was offered in golf, horseback riding, tennis, volleyball, archery, field hockey, basketball, baseball, track and field, badminton, softball, canoeing, camping, swimming, riflery, and in practically every type of recreation interesting to young women. The College of Industrial Arts was the first college to offer a degree in Health and Physical Education. The TSCW rifle team defeated the Texas A & M team for two consecutive years. (Unknown publisher, c. 1940.)

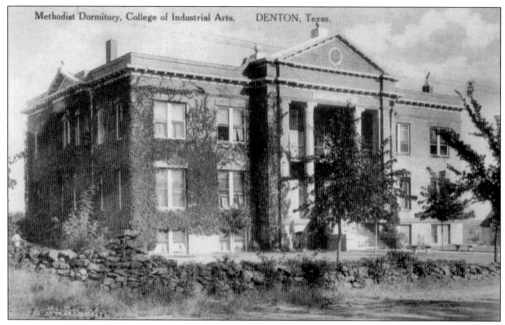

Methodist Dormitory, College of Industrial Arts. DENTON, Texas.

METHODIST DORMITORY. Because the college had no dormitory facilities when it opened, students boarded with private families or in boardinghouses. There were few homes near the college and no streetcars. Most students and faculty walked from a half mile to two miles to the school. Dormitories and sidewalks became high priorities. The Woman's Home Mission Society of the North Texas Conference of the Methodist Episcopal Church, South, sponsored construction of the first dormitory to house students. Methodist Dormitory, adjacent to the campus across Bell Avenue, could house 50 students. It was ready for occupancy in the fall of 1907. Girls preparing for mission work could combine the cultural and industrial offerings of the college with religious training provided in the dormitory. (Above, Albertype, 1908; below, Jones, Denton, 1908.)

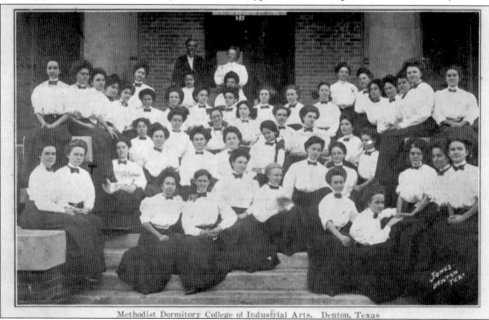

Methodist Dormitory College of Industrial Arts. Denton, Texas

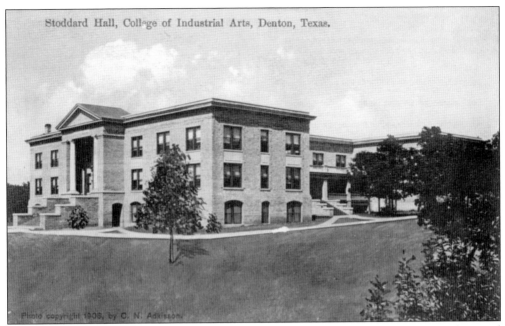

Stoddard Hall, College of Industrial Arts, Denton, Texas.

Photo copyright 1908, by C. N. Adkisson.

STODDARD HALL. When the first state-constructed dormitory on campus was completed in April 1908, the Texas Legislature named the building Stoddard Hall in honor of Helen Stoddard, one of the original Board of Regents members. One hundred students lived in Stoddard Hall, a more sound economic choice than living at home according to some of their parents. The college minimized costs by carefully buying foods and services for the dormitory and by applying some of the skills it was teaching. The students who lived in Stoddard Hall became known as "Stoddard Ladies," an alternative term for seniors who were entitled to live in Stoddard Hall. Costs in the dormitory ranged from $15 per month for a double room to $17 per month for a large, single room. The price for room and board included laundering of 15 items per week. Old Stoddard was torn down in 1935, and a new hall, also named Stoddard, was built on the same site. (Above, photograph by Prof. C. N. Adkisson, printed in Germany, *c.* 1908–1911; below, unknown publisher, 1908.)

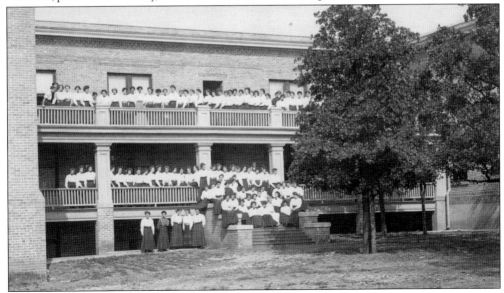

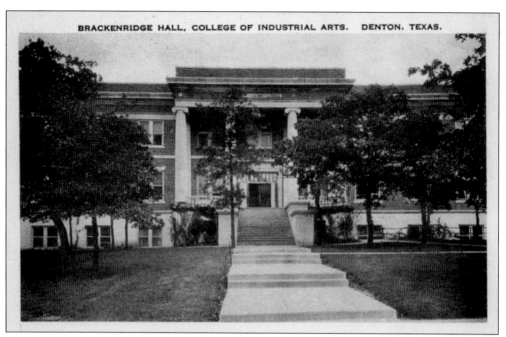

BRACKENRIDGE HALL, COLLEGE OF INDUSTRIAL ARTS. DENTON, TEXAS.

BRACKENRIDGE HALL. Brackenridge Hall, adjacent to Stoddard Hall, was completed in 1916 at a cost of $141,000. The dormitory, named for Mary Eleanor Brackenridge, who served on the first Board of Regents, accommodated 147 students in 73 rooms. A roof garden with a covered stage and seating for 1,400 people was a popular place for social gatherings. The basement dining room served about 500 students. The message on the postcard back reads, "This is where Lottie Stark, Frances Hamilton, and Ruth Seale room. Ruth rooms in the basement and Lottie and Frances on the second floor. This hall is near the Administration and Household Arts Building." (Whitson and McDade by Albertype, *c.* 1922.)

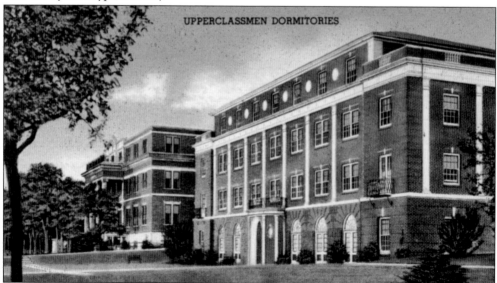

UPPERCLASSMEN DORMITORIES

UPPERCLASSMEN DORMITORIES. Brackenridge Hall (left) housed members of the junior class. The 1936 Stoddard Hall (right), the first air-conditioned dormitory, was home to members of the senior class. (C. E. Carruth by Curt Teich, *c.* 1936.)

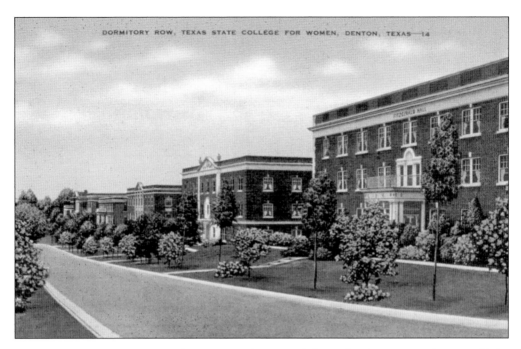

DORMITORY ROW. In December 1916, only 425 of the college's 1,038 students could be accommodated in dormitories. Pres. Francis Marion Bralley (1914–1924) received approval for two additional buildings. Lowry and Capps were added to begin "dormitory row" north of Old Main in the spring of 1918. By 1936, dormitory row included Brackenridge, Stoddard, Capps, Lowry, Sayers, Austin, Houston, and Fitzgerald. Thousands of students called these residence halls home through their college years until the 1980s when the dormitories were razed for the new library. (Above, C. E. Carruth by E. C. Kropp, 1936; below, Fultz News Agency by Curt Teich, c. 1936.)

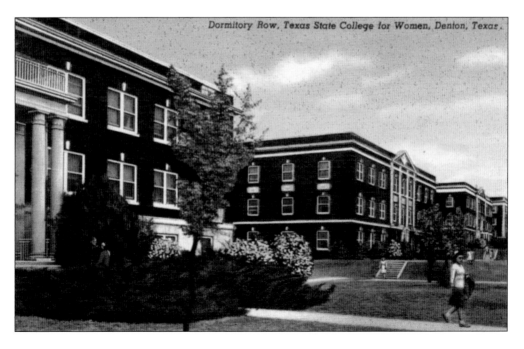

Dormitory Row, Texas State College for Women, Denton, Texas.

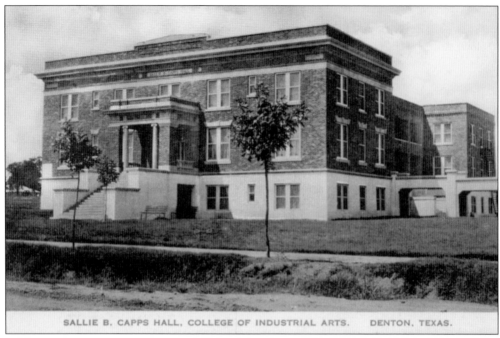

SALLIE B. CAPPS HALL, COLLEGE OF INDUSTRIAL ARTS. DENTON, TEXAS.

SALLIE B. CAPPS HALL. Capps Hall, built in 1918, was named for Sallie B. Capps, a former secretary of the Board of Regents. The hall cost about $115,000 and contained 72 rooms to house 159 students. (MC; Whitson and McDade by Albertype, *c.* 1920.)

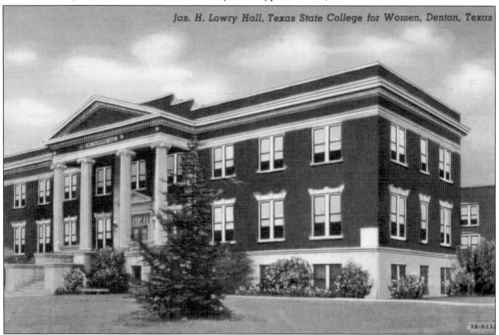

Jas. H. Lowry Hall, Texas State College for Women, Denton, Texas

JAS. H. LOWRY HALL. Lowry Hall was named for James H. Lowry upon his completion as president of the Board of Regents. Lowry Hall, built in 1918, was slightly larger than Capps Hall, cost $185,000, and included 84 rooms to accommodate 180 students. The basement dining hall served about 600 students. (Fultz News Agency by Curt Teich, *c.* 1936–1957.)

AUSTIN/SAYERS. Freshmen were housed in both Austin Hall (above) and Sayers Hall (below). Austin Hall, opened in 1936 at a cost of $175,000, was named in honor of Texas hero Stephen F. Austin and housed 200 freshmen students in 100 rooms. (C. E. Carruth by Curt Teich, *c.* 1940.)

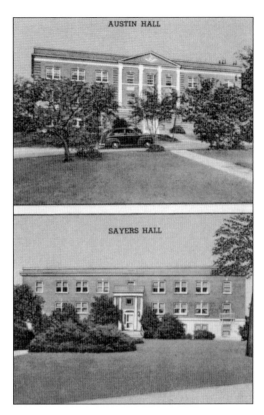

SAYERS HALL. Sayers Hall was named in honor of Gov. Joseph D. Sayers, who signed the bill establishing the Girls' Industrial College of Texas on April 6, 1901. Sayers Hall opened in 1928 at a cost of $175,000. The dormitory was a 92-room fireproof building that accommodated 202 students. (Unknown publisher, real photo, *c.* 1940.)

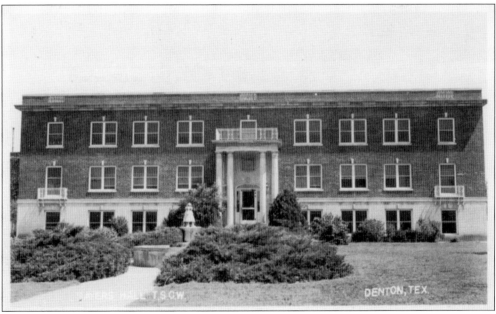

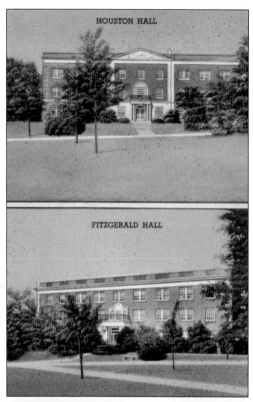

HOUSTON/FITZGERALD HALL. Sophomores of the college were housed in Houston Hall (above) and Fitzgerald Hall (below). Houston Hall, built at the same time as Austin Hall in 1936 at a cost of $175,000, accommodated 200 underclass students in 100 rooms. The dormitory was named in honor of Texas hero Sam Houston. Houston Hall had a rifle range under it in the 1940s. (C. E. Carruth by Curt Teich, *c.* 1940.)

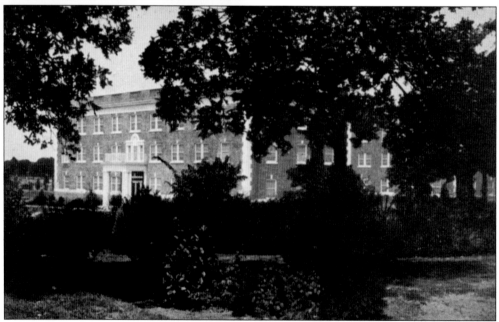

FITZGERALD HALL. Fitzgerald Hall was built in 1931 and named in honor of a former president of the Board of Regents, Hugh Nugent Fitzgerald. The three-story brick building accommodated 216 sophomore students in its 99 rooms. The $160,000 hall completed "dormitory row." (Unknown publisher, *c.* 1934–1936.)

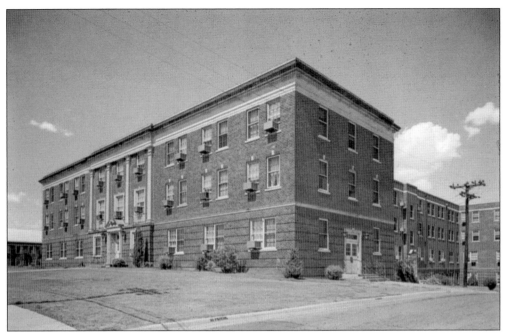

SMITH-CARROLL HALL. A new Smith-Carroll Dormitory opened in the fall of 1951 in the location of the Methodist Dormitory on Bell Avenue. It contained 134 rooms to accommodate 268 junior students. (Burchard's Studio, 1960s.)

MARY GIBBS JONES HALL. Mary Gibbs Jones Hall, built in 1961, was a new two-and-a-half-story structure designed to accommodate 332 senior women students in double rooms. Among special features of the building were ample parking and a patio. Like all the residential and instructional buildings that would be constructed during the rest of President Guinn's tenure, the dormitory was centrally air-conditioned and heated. Upon completion of Jones Hall, Stoddard Hall was converted to the use of sophomores. (Burchard's Studio, *c.* 1963.)

PARK VIEW LOOKING NORTH. The text printed on the back of this card reads, "This beautiful 27 acres was once the principal negro section of Denton, embracing some five city blocks. Through a bond election, this land was purchased and the negroes moved to another part of the city." This is a reference to the move of Quakertown, a predominantly African American community, which was moved to accommodate the first city park. Old Main is in the background of this postcard. (C. E. Carruth by E. C. Kropp, *c.* 1940.)

REDBUDS IN BLOOM. President Hubbard initiated a plan to add hundreds of redbud trees to the campus landscape. The college transplanted more than 2,000 redbuds to the campus, and many citizens in town joined the campaign to make Denton a redbud city. A weeklong Redbud Festival began in 1939, a highlight of the spring semester, with an emphasis on students' self-development, poise, and appearance. A Redbud Queen was chosen from the 60 princesses selected by the student body. (C. E. Carruth by E. C. Kropp, *c.* 1940.)

LITTLE-CHAPEL-IN-THE-WOODS. O'Neil Ford designed the Little Chapel. Master artisans supervised the work of 80 boys from Denton County in the stone, brick, and carpentry work with a grant provided by the National Youth Administration. More than 300 students, under the direction of art professor Dorothy (Toni) LaSelle, created the mosaics, stained-glass windows, brass lighting, altar fixtures, and the woodwork for the pews. First Lady Eleanor Roosevelt said in her dedicatory remarks on November 1, 1939, "May the use of this Chapel in the Woods be a blessing to you all." (C. E. Carruth by Curt Teich, 1950s.)

THE COLLEGE LIBRARY. The Bralley Memorial Library was completed in February 1927. The building experienced flooding problems and became inadequate for the needs of the students. The library was replaced by the Mary Evelyn Blagg Huey Library in 1986. (Unknown publisher, *c.* 1934–1936.)

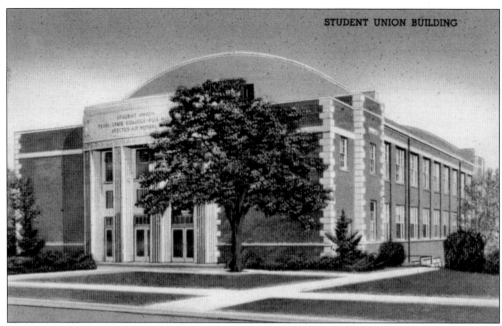

STUDENT UNION BUILDING. The Student Union Building was the center of campus activities. In 1941, a recreation building was constructed to serve as a physical education instructional space and club and activity location. A tunnel under Bell Avenue connected the Student Union with the gymnasium. (C. E. Carruth by Curt Teich, *c.* 1941–1957.)

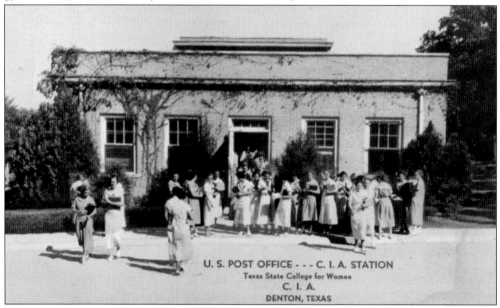

U.S. POST OFFICE COLLEGE OF INDUSTRIAL ARTS STATION. Before the U.S. Postal Service built the college campus station, President Work petitioned for the building of city sidewalks so that the college could receive free mail delivery. For a time, the janitor for the school served as mail carrier as well as custodian for Old Main. Construction of the post office building (fondly known by the students as the P.O.) was an event that warranted several scenic postcards to be produced celebrating this feat. (Unknown publisher, *c.* 1934–1936.)

PIONEER WOMAN. The *Pioneer Woman* statue was unveiled on December 5, 1938, to commemorate the centennial of Texas. Mrs. John A. Hann, a Denton pioneer, unveiled the 15-foot-tall statue. The *Pioneer Woman*, by Leo Friedlander, was made of Georgia white marble at a cost of $25,000. Pat Neff, former governor of Texas, delivered a tribute to the spirit of the Texas pioneer woman, and associate dean Jessie H. Humphries read the inscription that she had written for the pedestal of the statue. (Burchard's Studio by Dexter Press, *c.* 1970.)

HUBBARD HALL. Hubbard Hall, the central dining unit of Texas Woman's University, was dedicated in 1950. In addition to four student dining rooms, this $2 million facility housed various rooms for banquets and parties and the university laundry. The hall was named for Pres. L. H. Hubbard who served at Texas State College for Women from 1926 until 1950. (Burchard's Studio by Dexter Press, *c.* 1960.)

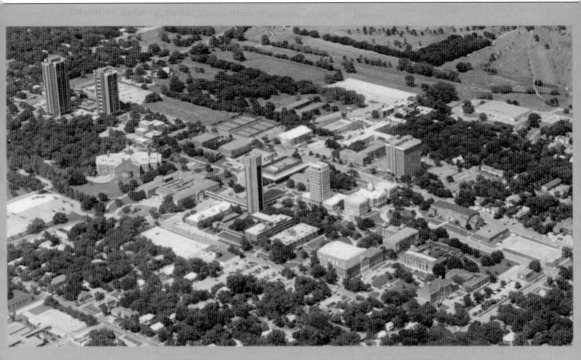

TEXAS WOMAN'S UNIVERSITY

AERIAL VIEW TEXAS WOMAN'S UNIVERSITY. As shown in this aerial view of the Denton campus, Pres. John A. Guinn, in addition to his many administrative accomplishments, changed the skyline of the city with his nontraditional style of architecture, including five high-rise structures. (Unknown publisher, 1990s.)

Eight

OTHER DENTON COUNTY COMMUNITIES

DENTON COUNTY EXHIBIT AT THE DALLAS FAIR. In 1910, Denton County presented an exhibit at the State Fair of Texas in Dallas that reflected the agriculture of the area. In the *Dallas Morning News*, the display was described as "neatly assembled and of an attractive appearance." Emphasis was placed on wheat and the award-winning flour produced from it. Other products of the county represented were oats, barley, rye, cotton, fruit, and pressed bricks. (Unknown publisher, 1910.)

OIL FIELDS. The note on the back of this card reads, "Cruscild [sic] oil field ner [sic] Denton. Russ Fleming and family." Oil was discovered in the Bolivar area of Denton County in 1937. Further developments in the oil industry were made in the 1940s. The Bolivar Oil Field continued to produce for several decades. Natural gas has become a rich industry in Denton County with the mining of the Barnett Shale, the biggest natural-gas field in the United States. (Unknown publisher, real photo, 1930s.)

JUSTIN COTTON GIN. Justin was founded as a stop on the Gulf, Colorado, and Santa Fe Railroad. It was named for the chief railroad engineer, Walter Justin Sherman. The first school and store were built in 1883, and in 1887 Justin had its first post office in the store. The postcard depicts a cotton gin in Justin. William I. Bishop purchased the cotton gin in 1922 and operated it until his death in 1952 when his wife, Alma Bishop, took over the business. She sold it in 1958. (Halldorson Brothers, 1914.)

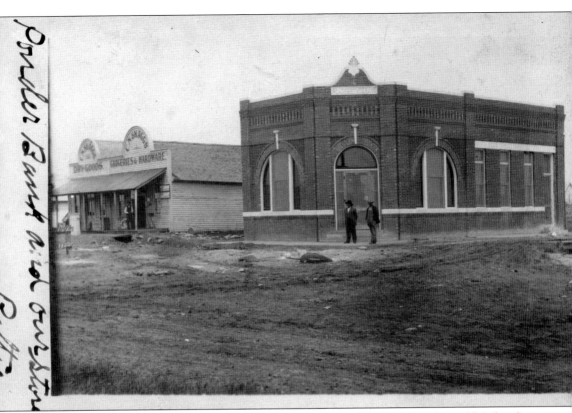

PONDER BANK AND C. N. SKAGGS STORE. Ponder was established in 1886 by the Gulf, Colorado, and Santa Fe Railroad. Originally called Gerald, the town's name changed to Ponder after Denton businessman W. A. Ponder when it was discovered that another town by that name existed. Ponder State Bank was built in 1908 and opened in 1910. It was voluntarily liquidated in 1935. It was robbed several times, but most famously in 1966 by Warren Beaty and Faye Dunaway while portraying the characters in the movie *Bonnie and Clyde*. (Unknown publisher, real photo, 1910.)

INSPIRATION POINT, PILOT KNOB. Pilot Knob is located 5 miles southwest of Denton near Interstate 35W. The sandstone knob is one of the most significant geological formations in the county. In the early history of the county, Pilot Knob served as a guidepost for Indian scouts, Texas Rangers, and pioneers. Legend has it that outlaw Sam Bass used Pilot Knob as a lookout and its cave as a hiding place. In later years, it was a popular picnic spot and home of the Pilot Knob Ranch until it was purchased by Perot Industries in 1987. (C. E. Carruth by E. C. Kropp, 1941.)

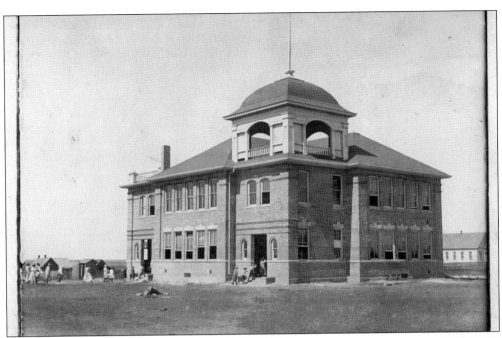

KRUM SCHOOLHOUSE AND PRESBYTERIAN CHURCH U.S.A.

KRUM. Krum was established by the Gulf, Colorado, and Santa Fe Railroad in 1886 and named for A. R. Krum, a vice president of the railroad. L. L. Finley sold the property to the railroad for the town site. The depot was completed in 1887 and a post office was established in 1888. The school moved from the Jackson community in 1891. A frame structure was built in 1901, and in 1910 this two-story brick school was built. It was torn down in 1976. The Krum Presbyterian Church was organized on June 29, 1901, in the schoolhouse. On June 30, 1911, the congregation dedicated a redbrick church located on First Street. Ownership of the building passed to the Presbytery Board when the congregation disbanded in 1942. (Above, unknown publisher, real photo, 1911; at right, unknown publisher, real photo, 1916.)

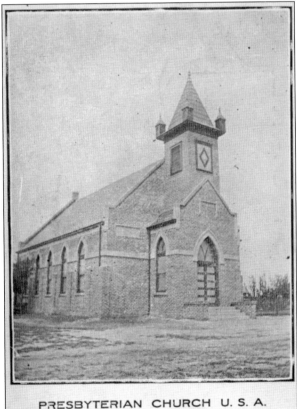

PRESBYTERIAN CHURCH U. S. A.
KRUM, TEXAS
ERECTED MAY, 1911.

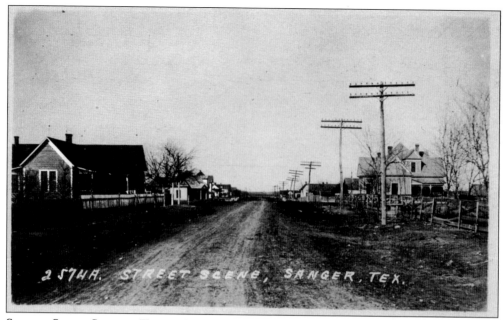

STREET SCENE SANGER, TEXAS. Sanger was founded in 1886 as a stop on the Gulf, Colorado, and Santa Fe Railroad after land was purchased from Mrs. Elizabeth Huling. After changing names several times, the town was named for the Sanger brothers, who operated department stores in Dallas and Waco and were patrons of the railroad. F. M. Ready, the father of the first child born in Sanger, served as the first postmaster. The town was first incorporated in 1892. (M. L. Zercher, real photo, *c.* 1900.)

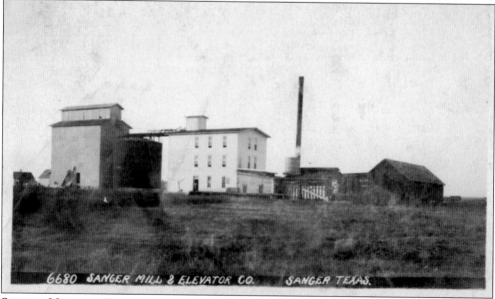

SANGER MILL AND ELEVATOR COMPANY. Sanger Mill and Elevator Company was established in 1897 by A. D. Miller. It was located on the east side of Second Street between Pecan and Plum Streets. Andrew Jackson Nance was the first president of the mill. One of the mill's major products was Silk Finish Flour. Kimball Milling of Fort Worth purchased the mill in 1941 and used it for grain storage. Grain continues to be stored and processed at the site today. (J. Bowers Photographic, 1909.)

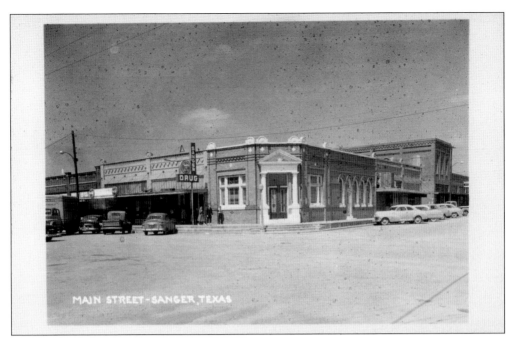

MAIN STREET SANGER, TEXAS. Bolivar Street serves as the main street through downtown Sanger. Originally known as Farmers Bank of Sanger in 1899, the bank was rechartered as the First National Bank of Sanger in 1905. The Sullivan Building, constructed in 1890 and the oldest building in downtown, housed city hall in the 1940s and 1950s. Other prominent downtown structures were the Wilfong Building and the opera house. (Both images, unknown publisher, real photo, 1950s.)

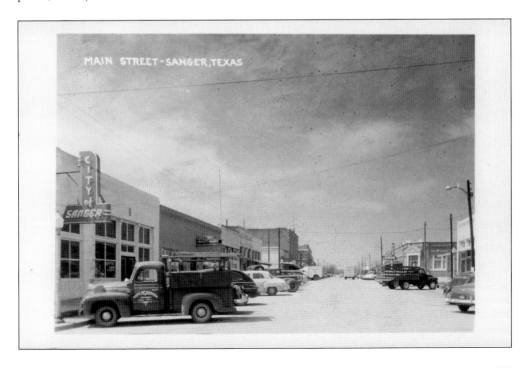

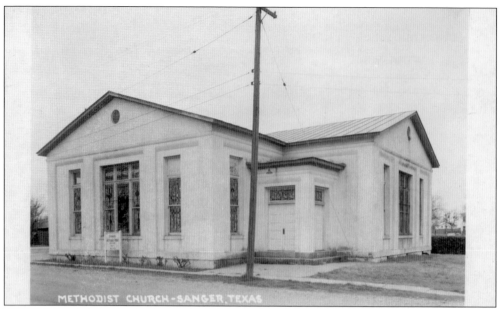

METHODIST CHURCH SANGER, TEXAS. The First Methodist Church of Sanger was organized on October 26, 1890, in the S. F. Peters' Store by Rev. S. W. Miller and 12 members. The congregation constructed the first church building in town, which was used by all denominations. In 1909, a new church was built on the corner of Locust and Fifth Streets. It served the congregation for 63 years. (Unknown publisher, real photo, 1950s.)

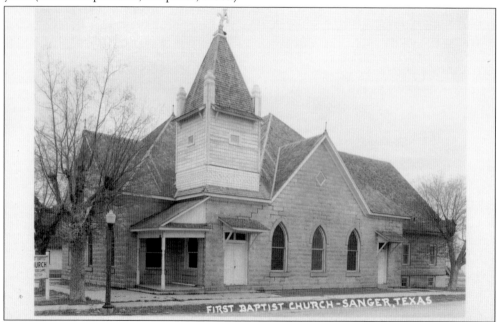

FIRST BAPTIST CHURCH SANGER, TEXAS. The First Baptist Church of Sanger was organized in April 1892 in the back of S. F. Peters' Store. The first church building was constructed in 1896. In 1906, a concrete block building was constructed at the corner of Cherry and Fourth Streets. In 1961, the congregation moved to its current location on Fifth Street, and the old church became Landmark Baptist Church. (Unknown publisher, real photo, 1950s.)

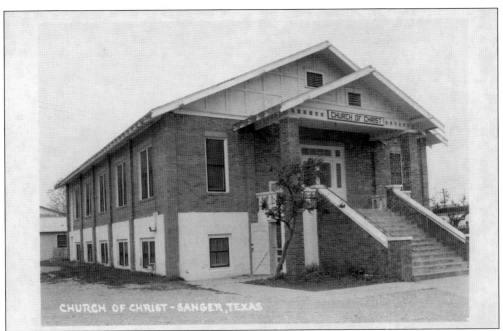

CHURCH OF CHRIST SANGER, TEXAS. The congregation of the Sanger Church of Christ met in the Odd Fellows Hall until the first church was built in 1903. In 1924, a two-story brick building was constructed and could seat 175 people. The church was torn down in 1962. A new church was built at Fourth and Cherry Streets in 1963 and served until the current building was constructed in 2003. (Unknown publisher, real photo, 1950s.)

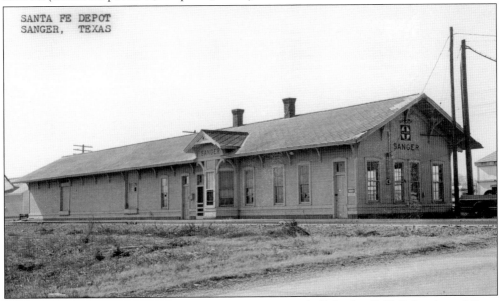

SANTA FE DEPOT SANGER. The first depot in Sanger was built by the Gulf, Colorado, and Santa Fe Railroad around the time the first tracks were laid in 1886. Fire destroyed this depot in 1890, and a new, larger depot was built on the east side of the tracks. It operated 24 hours a day, six days a week to accommodate the local farmers and the cattle going north. (Unknown publisher, real photo, 1975.)

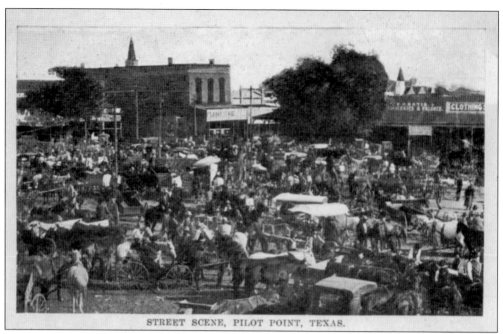

STREET SCENE, PILOT POINT, TEXAS.

STREET SCENE PILOT POINT. The town of Pilot Point was platted on Christmas Day 1853. The first resident to purchase a lot was Dr. R. W. Eddleman, who opened Star Drug Store, the first business on the square. The post office opened in 1855, and from 1858 until 1861 the Butterfield Stagecoach stopped in town. By 1895, Second Monday Trade Days were established, attracting 500 to 1,000 people a month. (M. L. Zercher, 1916.)

BIBLE INSTITUTE AND TRAINING SCHOOL PILOT POINT. The Pilot Point Seminary opened in September 1872 with an enrollment of 320 students. The large three-story frame building housed primary through college-level classes. The school was officially chartered by the state in 1884 and rechartered in 1892 as Franklin College. The school closed in 1900. (Unknown publisher, 1908.)

FARMERS AND MERCHANTS BANK.

UNION DEPOT, PILOT POINT, TEXAS.

FARMERS AND MERCHANTS BANK AND UNION DEPOT PILOT POINT. The Farmers and Merchants Bank was established in Pilot Point in 1899 by brothers D. W. Light Jr. and George Light. They constructed a large building at the northwest corner of the downtown square. The bank closed in 1930. (Unknown publisher, 1907.)

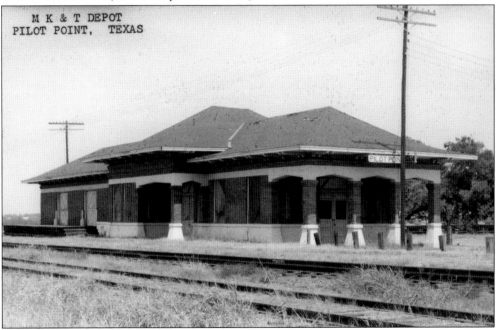

M K & T DEPOT
PILOT POINT, TEXAS

MISSOURI, KANSAS, AND TEXAS DEPOT PILOT POINT. The Texas and Pacific Railway reached Pilot Point in the fall of 1880. A wooden depot, pictured in this postcard, was built the same year. A few years later, the Missouri, Kansas, and Texas Railroad leased the right-of-way, and the two railroads shared the tracks and depot that served the town. In 1905, a new brick depot was built. (Unknown publisher, real photo, 1963.)

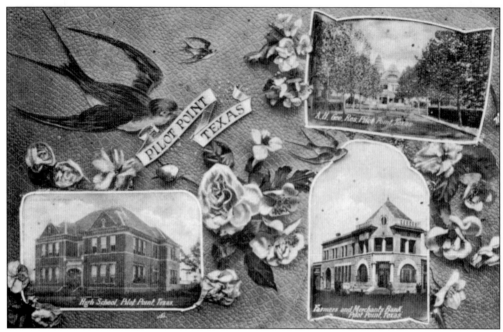

PILOT POINT MULTIVIEW. The message on the back of this card reads, "Here is a picture of the school building and 2 more buildings." The high school, pictured in the lower left, was built in 1898 and torn down in 1923. Despite its name, it served all classes. The other two buildings are the residence of Alexander H. Gee (top right), a prominent member of the community, and the Farmers and Merchants Bank. (Published by J. R. Peel, Pilot Point, printed in Belgium, 1909.)

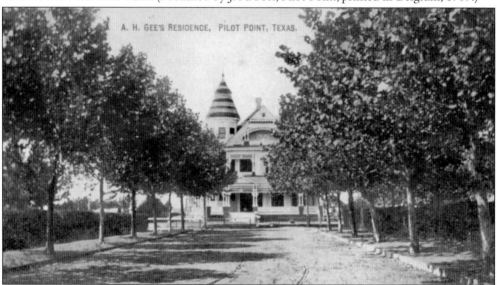

A. H. GEE RESIDENCE PILOT POINT. Alexander Hamilton Gee was an active community leader of Pilot Point. He was cashier and manager of Pilot Point Bank when it opened in 1884. He later served as the bank's president. He opened an opera house downtown in 1894. Gee built his large home in the 1890s. The house sat empty after Gee's death in 1929 and burned in 1943. The land was donated to the school district, and Gee High School was constructed on the site in 1951. (E. C. Kropp, 1909.)

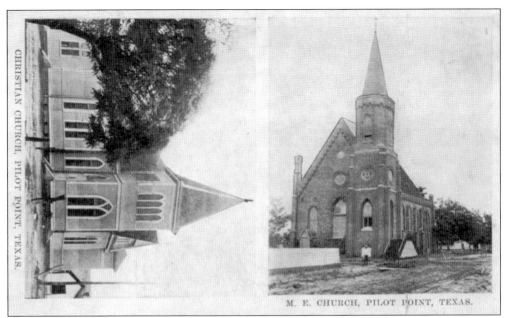

CHRISTIAN CHURCH AND M. E. CHURCH PILOT POINT. The Central Christian Church of Pilot Point was organized in 1901 by J. P. Adcock. In 1902, the congregation built a church on the corner of Church and Liberty Streets. The First Methodist Church of Pilot Point was established in 1856 by circuit minister William E. Bates. In 1871, the congregation partnered with the Masons to build a Masonic Hall and church. The Methodist congregation built a separate brick building in 1883. (Unknown publisher, 1912.)

CALVARY BAPTIST CHURCH PILOT POINT. Calvary Baptist Church was organized on October 15, 1907, by former members of the First Baptist Church. A church building was constructed in 1910 at the corner of Jefferson and Walcott Streets. Sunday school classes were added in 1921, and a new education building was constructed in 1948. A $46,000 sanctuary was dedicated in 1961. (E. C. Kropp, *c.* 1910–1916.)

123

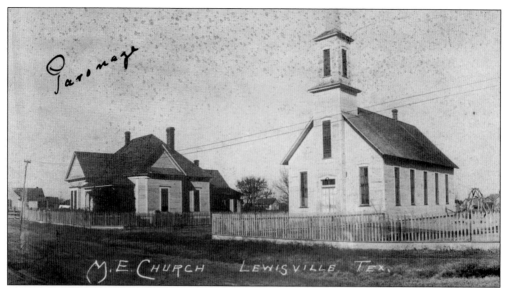

M. E. Church Lewisville, Texas. The first settlers arrived in the Lewisville area in 1844. It was originally called Holford's Prairie until Basdeal Lewis established the post office called Lewisville in 1853. The first church was constructed in 1868. The building also housed the first Masonic Lodge. Lewisville grew with the arrival of the Dallas and Wichita Railway in 1881. This postcard shows the Methodist Episcopal Church of Lewisville and its parsonage built in 1881. (W. S. King, *c.* 1902.)

Lake City, USA. The construction of Lake Lewisville and Interstate 35E increased the development of the city of Lewisville. Housing developments began advertising the close proximity to both working in Dallas and playing on the lake. Developer George C. Deutsch began building Lake City U.S.A., a development of 2,500 homes in Lewisville, in 1960. One home was advertised as the only three-bedroom brick home in America with a backyard swimming pool and priced below $12,000. Deutsch promoted the development with a Fourth of July event and donkey run from his development in Colorado. (Buena Vista Airography, 1961.)

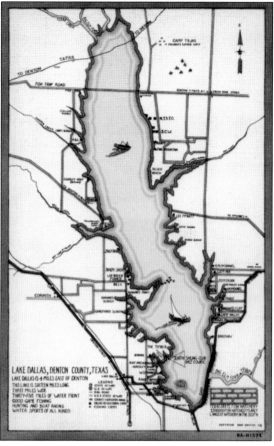

LAKE DALLAS AND SPILLWAY. Built by the city of Dallas as a water supply reservoir, work began on Lake Dallas in 1924 and was completed in 1927 at a cost of $5 million. Created by damming the Elm Fork of the Trinity River, the lake was 16 miles long and 3 miles wide and had a capacity of 70 billion gallons of water. Despite the debate over the use of the lake by the City of Dallas and Denton County, with Dallas wanting to limit recreational use, Lake Dallas became a popular leisure location. The spillway extended 3,500 feet and was a favorite fishing spot. (At right, Curt Teich, 1946; below, photograph by C. E. Carruth by Curt Teich, 1946.)

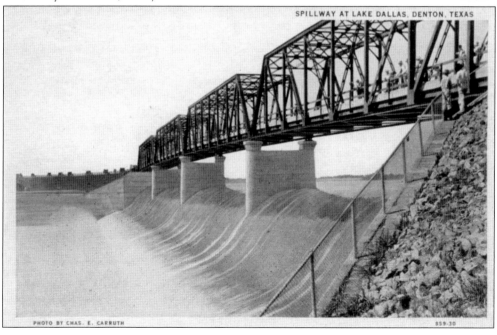

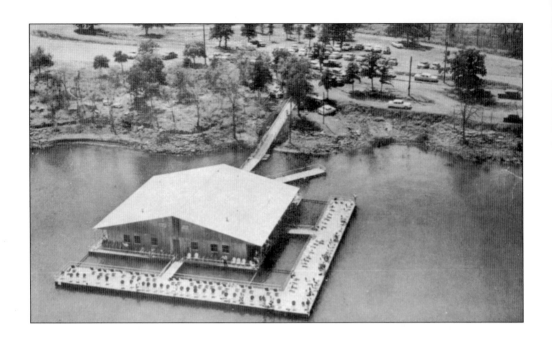

LEWISVILLE FISHING BARGE. Construction began on the Garza-Little Elm Reservoir in 1948 and was completed by 1955 as a project of the U.S. Army Corps of Engineers. The Lake Dallas Dam was breached on October 28, 1957, creating one large lake that was renamed Lake Lewisville in 1960. Fishing and boating were encouraged on the new lake. The Lewisville Fishing Barge opened in 1958. Advertised as one of the most modern in Texas, the 24-hour barge featured year-round air-conditioning, restrooms, television, a snack bar, and 300 comfortable chairs. The barge continues to be a popular fishing location today. (Both images, unknown publisher, 1960s.)

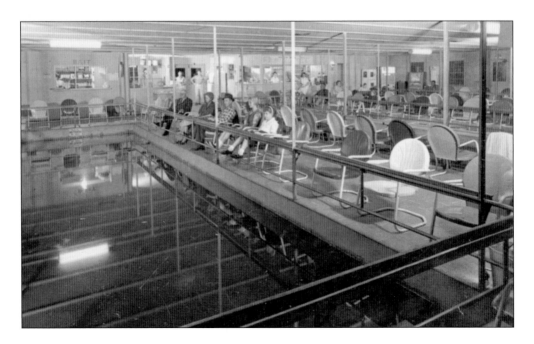

BAYLESS–SELBY HOUSE MUSEUM. Samuel Bayless and his wife, Mary, purchased a two–room farmhouse on Myrtle Street in 1884. Bayless added the two-story part of the house in 1898. He died in 1919, and Mrs. Bayless sold it to a neighboring nurseryman, R. L. Selby Sr. The Selby family retained ownership of the house until 1970. The house was moved to the Historical Park of Denton County in 1998 and opened as a museum. (Newts Games, 2008.)

DENTON COUNTY AFRICAN AMERICAN MUSEUM. Built in 1904 in the African American community of Quakertown, this house was purchased by C. Ross Hembry in 1919. He sold the land to the city in 1922 and moved the structure to Solomon Hill when the citizens of Denton voted to make the area a park and remove the neighborhood. In 2004, the house was moved to the Historical Park of Denton County and dedicated as the Denton County African American Museum. (Newts Games, 2008.)

www.arcadiapublishing.com

Discover books about the town where you grew up, the cities where your friends and families live, the town where your parents met, or even that retirement spot you've been dreaming about. Our Web site provides history lovers with exclusive deals, advanced notification about new titles, e-mail alerts of author events, and much more.

MADE IN THE USA

Arcadia Publishing, the leading local history publisher in the United States, is committed to making history accessible and meaningful through publishing books that celebrate and preserve the heritage of America's people and places. Consistent with our mission to preserve history on a local level, this book was printed in South Carolina on American-made paper and manufactured entirely in the United States.

This book carries the accredited Forest Stewardship Council (FSC) label and is printed on 100 percent FSC-certified paper. Products carrying the FSC label are independently certified to assure consumers that they come from forests that are managed to meet the social, economic, and ecological needs of present and future generations.

FSC

Mixed Sources
Product group from well-managed forests and other controlled sources

Cert no. SW-COC-001530
www.fsc.org
© 1996 Forest Stewardship Council

Find Your Place in History.